THE VAN GOGH ASSIGNMENT

KENNETH WILKIE

THE VAN GOGH ASSIGNMENT

PADDINGTON
PRESS LTD
NEW YORK & LONDON

**Library of Congress Cataloging in
Publication Data**

Wilkie, Kenneth, 1942–
 The van Gogh assignment.

 1. Gogh, Vincent van, 1853–1890. 2. Painters
Netherlands Biography. I. Title.
ND653.G7W54 759.9492 [B] 77–20966
ISBN 0-448-23167-0

Filmset in England by SX Composing Ltd.,
Leigh-on-Sea, Essex.
Printed in England by Garden City Press,
Letchworth, Herts.

Designed by Colin Lewis

In The United States
PADDINGTON PRESS
Distributed by
GROSSET & DUNLAP

In The United Kingdom
PADDINGTON PRESS

In Canada
Distributed by
RANDOM HOUSE OF CANADA LTD.

In Southern Africa
Distributed by
ERNEST STANTON (PUBLISHERS) (PTY) LTD.

For Lia

Acknowledgments

This book has been made possible because of many people. Most appear in the book itself, and I feel it is unfair to single out any of them. But not mentioned are two persons who, more than anyone else, I am indebted to. I thank Dick Ehrlich for his insight, understanding and encouragement and Lia Schelkens for her patience, tolerance and moral support throughout its preparation. Also a thank you to Ramses the dog for only eating one chapter.

Contents

Author's Note

I work for an English-language magazine, published in the Netherlands, called the *Holland Herald*. In 1972 I was given an assignment to write a feature article on the painter Vincent van Gogh. Its publication was to coincide with the opening of the van Gogh Museum in Amsterdam. The nucleus of this world-famous museum was the collection of hundreds of paintings and drawings sold to the Dutch government, for a princely sum, by Dr. Vincent van Gogh —nephew of the painter and son of Vincent's beloved brother, Theo van Gogh.

My assignment was to travel to the places where the painter had lived, photographing and making notes on the places as they are today. I didn't expect to find anything out of the ordinary—perhaps talk to a descendant of someone who had known van Gogh, or take an unusual picture of one of his houses. I naturally assumed it would be impossible to find anything new or important about van Gogh. He had died eighty years before I set out, and his life had been researched to the limit. There was, I believed, nothing new to be discovered.

That was what I thought.

I was so wrong. There is more to be found out even about

this most famous of painters—vital aspects of his life, new pieces of evidence that, through neglect or possibly even through deliberate cover-up, have never before been revealed. This book presents the discoveries I made, and tells the story of how I made them.

I ultimately wrote it to satisfy myself and the many people who are fascinated by Vincent van Gogh. Some of what I say will interest art historians, but they are not my hoped-for readership. Van Gogh himself wrote that he tried "to paint for those who do not know the artistic aspect of a picture." This book is for those same people—those who love van Gogh not merely because of the greatness of his art, but because of the passion of his humanity.

Part One

Chapter one
Go

On an icy morning in January, 1972, I found myself lying face up in the middle of a narrow canalside road, wedged between my bicycle frame and the legs of an American tourist.

I had been pedaling sleepily to work. He had run out from behind a tree.

"I'm sorry," we said simultaneously, having cursed each other inwardly for a second. I cracked a feeble joke, trying to make light of a situation that must have been funny to watch. As we disentangled—slowly, and with great difficulty—he spoke: "I'm looking for the van Go Museum. Can you tell me if I'm near it?"

"The what museum?" I thought fuzzily of Go... Stop... green light . . . red light . . . red light district . . . red . . . blood! There was blood trickling from his nose into little red icicles in his moustache. Had he damaged his head?

He repeated: "You know, Van Go—the guy who cut his ear off. The painter." There was a note of impatience in his voice. It dawned on me. The problem was one of pronunciation.

"Oh, sorry . . . You mean Vincent van Gogh?" ("G" in Dutch is pronounced like "ch" in the Scottish "loch." It's

always come naturally to me, and living in Amsterdam I was unused to the American version.)

"Yeah, that's him. You've got it." The man had forgotten all about the accident. He looked amiable when he smiled. After all, it was early in the morning when most tempers are easily frayed and many people would have taken exception at being bowled over by a hairy Highlander pedaling at full pelt. I took a liking to him and realized that it was a waste of time taking him to a doctor.

"Are you sure you're all right?" I asked. I felt it was about time one of us said that. "You have a nasty bump on your head."

"I'm fine. The bump? That's my nose. . . ." Laughter as car tooters pierced the morning air. We were holding up traffic. "And you?" he asked. We shuffled over to the side of the road.

"It's woken me up," I replied. "I've learned to live with the unexpected in Amsterdam. It's around most corners. A morning's not the same without a multiple fracture."

Now that we were standing at the side of the road I got my first good look at the man. He was tall and lean, dressed neatly in blue jeans and turtleneck sweater. Nothing unusual apart from the scarlet stalactites in his moustache. That, and a strange look in his eyes. As we chatted, I realized what it was: when he talked about van Gogh, he got this look of mild-mannered fanaticism. He told me that he studied psychiatry and painted in his spare time, and had come to Amsterdam primarily to see the van Gogh Museum.

I hated to disappoint him, but had to inform him that all he could see of the van Gogh Museum at this stage was its foundations. Building had only begun, and van Gogh's paintings were still being housed in the Stedelijk (Municipal) Museum next door in Museumplein. This didn't matter, he said. As long as he could see some paintings. He was interested only in the paintings.

As I would be passing through Museumplein on my way to work, I offered to give him a lift on my bike. With a look of terror in his eyes, he said he would prefer to walk. I told him how to get there and we said goodbye.

I never did ask his name, but I never forgot that look of fanaticism in his eyes when he talked about van Gogh. I would encounter it again and again among people who in some way related to this painter. It was a look that van Gogh himself would have easily recognized. As I cycled on, I contemplated the power this painter had. That incident in winter had kindled my curiosity.

By the time the spring crocuses were out on Museumplein, the van Gogh museum had begun to take shape. The huge concrete cubish structure rising above the trees was designed by Gerrit Rietveld, the "De Stijl" architect, shortly before he died. Its stern angularity reminded me more of a monument to Piet Mondrian than the building destined to house over 600 works by one of the most passionate painters of all time.

As spring was giving way to summer, the name Vincent van Gogh appeared on the museum's façade in large white letters. I became used to seeing his name up there in concrete. It served as a reminder of how little I knew about him.

A few years before, when I was living in a cottage in the Scottish Highlands, a friend had given me a copy of Vincent's letters to his brother Theo. I remembered being struck by their humanity and intensity of feeling. And later, when cycling through Provence, in the south of France, Vincent's descriptions of the landscape echoed in my mind. But that was all—and here I was living in his native country, the Netherlands, cycling past his name in concrete every morning.

The museum, I had learned, was to officially open in March the following year. A story about the life of van Gogh to coincide with the opening seemed right for my magazine, the *Holland Herald*. I mentioned the idea to editor Vernon

Leonard, who gave his approval. In our discussions of what form the article should take, he suggested that I try following van Gogh's footsteps—visit the places where he had lived—and see what I found. The approach sounded right, being essentially similar to the way I had done an article a few months before on the painter Piet Mondrian. I was not a complete stranger to articles on painters. In the course of my research on Mondrian I had found one of his old flames in Amsterdam—she was my landlady.

For the van Gogh assignment I would be given 1,500 guilders (about $600) and three weeks to do my research. There was no specific goal, no list of things to do. Just travel with notebook and camera, and keep my eyes and ears open.

As I made plans, I became aware of the practical difficulties in what I was trying to do. In his thirty-seven years, van Gogh lived in eighteen different places in Holland, England, Belgium, and France. I soon realized that, taking in travel time, I couldn't go everywhere. Nothing like it. I had to budget my time carefully. Poring over maps of Europe, I decided that train travel would be too inflexible, so I would take my car. But even with the car it would be impossible to cover every place where van Gogh lived.

First of all I wanted to meet the people who were involved with the museum. At that time the van Gogh family archives were being temporarily housed in a little office in Honthorststraat, a side street off Museumplein. I went round there one morning and introduced myself, and received a very warm reception from the people who were running it: Lily Couvée-Jampoller, Loetje van Leeuwen and museum director Emile Meijer. Their ideal was to make the place a total, living concept: a place where people could walk off the street, pick up a brush and start painting—as well as a museum to exhibit the largest collection of van Gogh's work, and a major study center for students and scholars.

Everyone I talked to at the museum was interested in my assignment, and several people went out of their way to be helpful.

Lily Couvée-Jampoller lent me a copy of the definitive study of Vincent's life and work by Dr. Marc Edo Tralbaut. "Tralbaut spends a lot of his time in the south of France. He has a house in Maussane, near Arles. I'll give you his address," said Lily. "And when you're in London you may be interested to contact Paul Chalcroft. He is a postman who came to visit us last year. In his spare time he paints and is totally inspired by van Gogh. He's also been doing some research into Vincent's life in London." I scribbled the name Chalcroft in my notebook.

After talking for a while, Lily showed me to the archives, where I had plenty of background reading to do. I was confronted there by shelves of books on van Gogh: psychological studies, God knows how many critical works, potted biographies. My initial reaction to all the reading matter available was simple bewilderment: "Where could I begin?" There was so much here I could spend my three weeks reading and never leave Amsterdam. And besides, with every period of van Gogh's life so well researched, I would never come up with anything interesting, let alone original. But as I leafed through volume after volume, I realized there was more to be done than I had at first suspected. Parts of the painter's life seemed still uncharted. His years in Paris and London and in Belgium had been overshadowed by his latter days in Arles.

I made notes like: Who was landlady's daughter London. Rejected him. Made him religious fanatic. Descendants? Photos?

The drama of van Gogh cutting off part of his ear has been told ad infinitum, but what of the scant references to his two years in Paris living in a flat with his brother Theo, and a man called Andries Bonger?

As I read and took notes, I began to feel very much at

home in this little improvised library. I was downing my fourth cup of coffee and looking at a self-portrait of van Gogh when the door creaked open. When I looked up, I did a double-take. Standing in the doorway was a white-haired elderly man. He wore a neat dark suit and a little striped bowtie. And he looked remarkably like the face on the page in front of me.

"Van Gogh," he said, extending his hand in my direction. Is this a password? I wondered. Then I remembered the Dutch custom of introducing yourself by announcing your name as you shake hands. I grabbed his hand and blurted out "Wilkie." Now what happens? I thought.

Lily had been standing nearby and noticed the look of bewilderment on my face. Hurrying over to where we were standing, she introduced me to the man who was Vincent van Gogh's namesake nephew, Dr. Vincent Willem van Gogh. With his high forehead and Roman nose, Dr. van Gogh—or "the Engineer" as everyone at the museum refers to him—looks more like his uncle Vincent than his father Theo, Vincent's devoted brother who inherited so many of Vincent's paintings and drawings. The Engineer was only a year old when Vincent held him in his arms. That was a couple of months before he committed suicide in July, 1890.

Now he was standing next to me, eighty-three years old. He seemed willing to talk, so I took the opportunity to ask him how it had felt to grow up with 200 paintings and 400 drawings by his uncle Vincent. We sat down across from each other and he replied in a business-like, matter-of-fact manner:

"Oh, our house was stacked full of them—under beds, on top of wardrobes, under the bath, and, of course, on the walls," said the Engineer. "My father kept them all you see because, although he couldn't sell any when Vincent was alive, he was convinced that one day his brother would be to art what Beethoven was to music. When my father died

(only six months after Vincent), the collection was passed on to my mother, Johanna van Gogh-Bonger, and then down to me."

Bonger . . . I had just read that name. I circled it in my notebook.

The collection remained the personal property of Dr. van Gogh until 1962 when, at the suggestion of the Dutch government, a foundation was set up in Amsterdam with Dr. van Gogh as president. The State subsidised the foundation to buy the collection for $5½ million while providing funds to safeguard the Engineer's descendants. The government also pledged to erect a special building for the collection on Amsterdam's Museumplein. And this was the van Gogh Museum.

Dr. van Gogh retired as a consulting engineer in 1966 and lives today in a thatched mansion in Laren, a village twenty miles east of Amsterdam. I asked him if being Vincent's nephew had affected his personal life and he replied: "Not in the slightest. In my work I have had to deal mostly with industrialists who are usually not interested in painting. But you know, what happened in Vincent's life happens to us all in a lesser degree. Part of the reason for his popularity today is that others recognize things in themselves that happened to him. You're never the same person after reading his letters. He was so many-sided."

Later, in the course of my research, I would be talking to Dr. van Gogh again about some family matters that had remained shielded from the world. Now I hurriedly looked through my notes and saw the name "Bonger" circled. That name, thrown out in conversation, had rung a bell with me. The engineer's mother was Johanna van Gogh-Bonger. Bonger was the name of a man whom Vincent and Theo had lived with in Paris. I asked the Engineer about this relatively obscure episode.

"Vincent's life in Paris . . . I understand that not much is known about it?"

"True," replied the Engineer. "You see, he was living most of the time with Theo then and consequently didn't write so many letters."

"You mentioned the name Bonger. That was your mother's own name, was it?"

"Yes."

"Was she related to the Andries Bonger who lived with Vincent and Theo in Paris in 1886?"

"Yes, my mother was Andries Bonger's sister."

"Bonger is dead, I assume. Did he marry?"

"Yes, twice."

"Is either of his wives still living?"

"His second wife, Françoise."

"Do you know where she is living? Would she be willing to see me?"

"Yes, she lives in Almen, in the east of the country, and I am sure she would be willing to talk to you. But I doubt if she would know very much about the Paris period. That took place before she knew Andries."

I decided to phone her right away. Even if it was a long shot, it was a start, and surely Bonger had told his wife something about his life in Paris.

Lily showed me a room where I could find the telephone number and talk in private. The directory for Almen listed Françoise Bonger, Baroness van der Borch van Verwolde. Quite a mouthful. How do you address a Dutch baroness?

I dialed her number and a soft voice answered the telephone, identifying herself as the Baroness. I explained my assignment and why I wanted to talk to her. She replied:

"Well, you may or may not be interested in my memories." But she invited me to her home and we arranged an appointment for the next day.

I was full of anticipation as I put down the phone. Here was a woman whose husband had actually known van Gogh, lived with him. A few moments before I had talked with a man who, when he was a baby, had been held in the

painter's arms. Whatever else I had expected from my article, I hadn't expected to find people whose lives were touched (even marginally) by van Gogh. These people made the great man seem a little less remote. In their different ways, they shared a living link with him. The possibility that there were others like them made me decide to stop trying to absorb the mountains of literature and concentrate on people. I thanked everyone at the van Gogh Museum-to-be for their kindness and help.

"I will be taking photographs as I go along," I told director Emile Meijer, "but can I use photographic material from your archives if I need it to illustrate the article?"

"Of course," he replied. "But you never know what you'll come back with, do you?"

"That's true," I said, fully expecting to return with little except eyes like crumpled road maps. I knew well how much had been written about van Gogh.

Walking out of the museum, I stopped to watch some workmen assembling a staircase. I admired, a little enviously, the strict logic with which they did their work: section by section, piece by piece. Hoping that I might learn something from their example, I tried to collect my thoughts. I still lacked a definite goal to my article, but I had a beginning: I wondered whether there were other old people in Holland, apart from the Baroness and Dr. van Gogh, who had similar links to the painter's life. Vincent left Holland for the last time in 1884, so any person alive today who knew him could only have been a child then and nearly a centenarian today. It was a long shot, but worth trying. The idea had a strange logic about it.

Vincent's last Dutch days were spent in 1884 in Nuenen, a weaving village in the south of the country where his father was the local minister. I remembered reading in Tralbaut's book that there were a few little boys who collected birds' nest for him and watched him paint. One of

them, named Piet van Hoorn, had talked to a journalist about the experience back in the 1930s. Could van Hoorn possibly still be alive? If so, he would be well into his nineties, or even older.

Back at the *Holland Herald* office, I went to the telephone book again—for the Nuenen area this time. There was one van Hoorn listed, and Laura Kelder, editorial secretary, phoned the number for me. Laura explained what I was doing and that I was trying to find out if a certain Piet van Hoorn was still alive. He was a miller who lived at Opwetten, near Nuenen.

Laura listened for a while to the woman who answered the phone and then turned to me: "Ken, she says she is Piet van Hoorn's niece and that Piet is still alive. He is ninety-eight."

"Ask her if he remembers Vincent van Gogh," I said.

"Yes," said Laura. "She says that although he is very old he is still very active and there is nothing wrong with his memory." This was too good to be true.

"Would he be willing to talk to me tomorrow?" Yes. Fantastic. We arranged a time.

That night I felt tremendous enthusiasm as I planned my trip. I left Amsterdam just before dawn the next day, September 13. By the time the sun came up, I was in the countryside. The sky was cloudless, casting long shadows over the dewy fields. I was full of anticipation and not a little optimistic about the day ahead.

I had planned to make a detour on my way to Nuenen and briefly visit the village of Zundert, where Vincent was born. It took just under two hours to reach Zundert, a small parish south of Amsterdam and about five miles from the Belgian border in the province of North Brabant. The gaunt house where Vincent was born stands directly opposite the old town hall in the village square. I walked the short distance from the manse to the churchyard—the route Vincent must have followed every Sunday as a child.

Near the graveyard gate I stumbled on a little grave-stone, much smaller than the rest. Inscribed on it was the name Vincent Willem van Gogh. This was the van Gogh family's first child, who was stillborn on March 30, 1852. Their second, whom they also called Vincent Willem, was born a year—to the day—after his stillborn predecessor.

Here I was, at the beginning of my journey, contempla-ting a forgotten gravestone. What a strange effect it must have had on Vincent as he passed that tombstone with his name engraved in it. A constant confrontation with the idea of death. Conceived in sadness, was he a melancholy man in the eyes of a boy who knew him? After taking a few photographs of the first Vincent's gravestone, I set off for Nuenen to find out.

The country roads from Zundert to Nuenen are lined with poplar trees, the regular patterns broken every so often by a farmstead. When I saw a woman at a farm-house door wearing her poffer, the traditional white head-dress of North Brabant, it reminded me of the women in van Gogh's *Potato Eaters,* who were wearing the same hats then. Occasionally in the fields near Nuenen where Vincent had roamed with his canvas and paints, I would see a farm worker bending in the fields or plowing. It reminded me so much of the studies van Gogh made of peasants in this area 100 years before.

Entering Nuenen, I recognized, from a painting he had made of it, the little hexagonal church surrounded by a clump of trees where Vincent's father preached. Down the road was the manse where the van Gogh family lived. It was a large detached house, surrounded by ivy and exuding an atmosphere of mysterious calm. I stopped at the door-way—remembering that this was the spot where Vincent's father was stricken with a fatal heart attack after returning from a walk in the country.

I knocked on the door and it was answered by a fresh-faced man in his late thirties. I explained who I was and he

told me he was the new parish minister, the Reverend Bartlema. I was shown the wash house at the back of the manse where Vincent used to paint before he left the household. The back garden that he had drawn and painted had been shortened, but some trees were still recognizable from his pictures.

Bartlema told me how to reach the watermill at Opwetten, on the outskirts of Nuenen. Until I told him, he was unaware of the significance of its occupant.

The old watermill remains almost exactly as it was in 1884 when Vincent painted it. Separated from the mill by a line of flat-topped trees is the miller's house, an eighteenth-century building, again with ivy clinging to the brick. As I walked toward it, I thought that it too had changed but little.

The door was answered by Piet's niece, a sturdy countrywoman in her fifties. She was expecting me.

"Piet's over at the mill." She pointed. "Although we don't use it for cutting wood or grinding corn any more, Piet likes to keep it in working order. He says you never know when there'll be a power cut."

We walked over to the sluice. An old man was leaning on the fence, looking thoughtfully down at the mill-pond below. It was Tuesday, but he was wearing his Sunday best—a dark striped suit, black hob-nail boots, collar, tie and cloth cap. A gold watch chain dangled from the breast pocket of his waistcoat. As we approached he took out his watch to check the time, and a smile crossed his face.

"Five minutes late. Not that five minutes either way makes much difference at my age." There was a glint in his keen old eyes. "It's just a habit I have."

Piet told me he would be ninety-nine in a couple of months. It was hard to believe that on this, my first day on the road, I was talking to the last man alive who had talked with Vincent van Gogh. And here he was talking to me where he had talked to Vincent, nearly ninety years

ago, by the watermill where he was born. I asked him about his life.

"I have never strayed far from Opwetten," he said. "I stopped working the mill here seventeen years ago when I was a young man of eighty-two and I have certainly had time enough to recall the people I have known."

"When did you first meet Vincent?"

"Oh yes, my old friend Vincent. Well, nobody could forget him. I was ten. But I remember it like yesterday, seeing that red-bearded man with the paints. The first time I saw him he was sitting in the road over there. It was a sunny afternoon like today."

"How did he look?"

"He was wearing a straw hat and a kind of farmer's smock. Blue. He had a pipe in his mouth all the time. I hadn't seen anyone like him before. My schoolmates and I used to gather round and ask him questions, but he only gave short abrupt answers."

Piet's path would often cross Vincent's in the fields around Nuenen.

"I used to see him on his knees, holding his hands up to his eyes." Piet crouched, imitating the painter. "Then he would sway from side to side, tilting his head from one side to the other. Some people thought he was mad. I guess I can understand why."

Piet showed me around the mill, explaining in detail how the corn was ground till not so long ago by water power. After I had taken some photographs, we walked over to the house, where we sat in the dim light of the big Dutch kitchen. Against one of the tiled walls stood an old grandfather clock. In this timeless atmosphere, its slow tick was the only sound to be heard. Piet was sitting in a farmhouse chair by the stove. As he talked, every so often he would take out his watch and check the time against the grandfather clock. He was looking out the window toward the cornfields and pointed in their direction.

"One day I met Vincent in that field over there. He asked me if I could find the nest of a golden oriole for him and bring it to where he was living in Nuenen." The golden oriole was not a common bird, but Piet knew the nesting places and ultimately found one high up an oak tree.

"The nest was wedged in a fork of two branches so I took the nest and branches together to Vincent's studio. He told me that he was living in the house of Schafrath, the caretaker of the Roman Catholic church at Nuenen. When I reached there, the door was open so I walked in. Vincent was painting and he didn't notice me. 'I found your nest, Mr. van Gogh,' I said. But he didn't hear me, or, if he did, he paid no heed. The studio was what you might expect. Ashes were piled up around the stove. Shelves and cupboards were full of birds' nests and plants that he had probably picked while out on his rambles. I remember a spinning wheel too and all sorts of farmers' implements. Some dry bread and cheese lay on the wooden table. Vincent was a strange sight. He was dressed only in his long woolen underwear but was wearing his straw hat and smoking his pipe. He was painting trees. He walked three paces one way and then three paces the other. I had never seen anyone like him. 'Mr. van Gogh,' I said, a bit louder. But he didn't hear. He sat in a chair some distance from the easel and stared at the painting for a good long time. Suddenly he would leap up as if to attack the canvas, paint two or three strokes quickly, then scramble back to his chair, narrow his eyes, wipe his forehead and rub his hands. Not until he finally seemed satisfied with the results did he look around and notice me standing there. When he saw the nest and branches, his eyes grew large. He put down his palette and took the pipe out of his mouth. He exclaimed: 'Well done, lad!' "

Piet filled his own pipe, then demonstrated how Vincent looked at the nest from all angles. "He never gave me more

than fifty cents for a nest, but that was a lot in those days for a boy of ten."

"What did you think about Vincent?"

"Well, they said in the village that he was cracked, but he never gave me that impression. He appeared odd only because his way of life was different from others in the community."

"When Vincent finally left Nuenen, the verger Schafrath piled all the painter's 'rubbish' together and burned the lot. There were stacks of canvases and drawings made during his stay in Nuenen. Poor Vincent. I remember feeling very sad when I heard he had gone."

I could see the old man was getting tired. There would be long pauses between his sentences, and his voice sounded a bit hoarse. But as I sat there in the failing light of his parlor, I marveled that this man was recalling experiences he had had nearly ninety years ago. And as I took my leave, I reflected that I was getting a glimpse into van Gogh's life just before it passed beyond the reach of human memory.

I said goodbye to Piet and walked across the fields toward a clump of trees that Piet had told me concealed a small graveyard overgrown with moss and ivy. Vincent's father was buried there. The sun was sinking in the sky and cast a sheen of gold over the ripe heads of corn swaying in the warm breeze.

In the graveyard I cleared away the earth and foliage to photograph Vincent's father's tombstone, which seemed to have been forgotten. A forgotten life and a forgotten death. A pattern had already begun to form in the journey. Would every van Gogh gravestone lead me to a living link with the painter? I hoped not—there were a lot of dead van Goghs and I had a deadline to keep to.

I would never see Piet again. He died on November 25, 1974, a week before his 101st birthday.

It was a warm, balmy night, and I slept out in my old Scottish sleeping bag. I awoke with the birds just before

dawn and set out for Almen at sunrise. My success with Piet propelled me on with a feeling of optimism.

Almen lies in the Gelderse Achterhoek, an eastern enclave of the Netherlands. Here the unrelenting flatness of the reclaimed west part of the country gives way to more natural wild woodland.

The Baroness told me on the phone that anyone in the village would be able to tell me how to get to her home. So I took her advice and approached the first person I saw.

"Could you tell me how to get to the home of Françoise Bonger, Baroness van der Borch van Verwolde, please?"

"Who?" The woman looked me up and down suspiciously. I repeated the question.

"Never heard of her. There's a butcher called Bonger down the street, ask him."

Butcher Bonger was no relation to Baroness Bonger, but he did tell me how to get to her home.

The Baroness lived in an elegant eighteenth-century manor house at the end of a winding, wooded drive. Sheep were grazing on her front lawn, which tapered away into an apple orchard. A river ran through the bottom of the valley beyond. On the porch stood the Baroness, a slender, elegant lady dressed in black-and-white lace. She was feeding the guinea fowl that pecked away at the sunflowers outside the house. Once again I was reminded of van Gogh, who loved these flowers so much.

The Baroness extended her hand in an aristocratic manner. Indecisive at first whether to kiss it or shake it, I settled on the latter. She ushered me into the drawing room, where tea was served by her maidservant. The walls were full of pictures by artists like Odilon Redon and Emile Bernard, who was Vincent's close friend in Paris. The Baroness noticed my interest in them. "Yes, there are some very beautiful paintings here," she said. "They were mostly given to Andries, my husband, in Paris. He knew so many painters there."

"He knew van Gogh, too?" I asked, hoping she would elaborate.

"Well, he knew Vincent better than any of the other painters," she said. "As you know they lived together for a while. Vincent gave Andries that self-portrait with the gray hat. I'm sure you know it. It is now part of the collection in the van Gogh Museum. Actually, it was Theo's hat, Andries told me, and not Vincent's. Apparently Vincent used to wear out all his brother's clothes."

It didn't take me long to realize that the eighty-six-year-old Baroness had a memory as vivid as Piet van Hoorn for the stories her husband told her about his stay with Vincent in Paris—two years after Piet knew him in Holland.

Vincent's Paris period, as Dr. van Gogh had mentioned, had remained a blank largely because Theo and Vincent were living together, and the primary source of information —the correspondence—was non-existent. Although it yielded at least two hundred paintings and fifty drawings, only seven letters have been preserved from Vincent's two years in the French capital. But how much had Andries Bonger told his wife?

Seated in her Victorian basket chair, by the window, Baroness Bonger needed little prompting from me as she recalled her late husband's stories about the bizarre summer he spent in Paris with the van Gogh brothers:

"Andries was an insurance agent. He met Vincent for the first time in Nuenen, where you've just come from. Andries said that Vincent didn't take any part in family life and struck Andries as being decidedly odd. His face was tense, Theo's calm.

"They met again in Paris a couple of years later. It was the summer of 1886 and Vincent was studying at Cormon's studio in Montmartre, I believe. Vincent had moved into Theo's flat at rue Lepic, and Theo—he was having a terrible time coping with Vincent—asked Andries to come and live there also. Which he did.

"Neither Vincent nor Andries had much money, so they jointly bought the books they wanted to read. Here is one of them," said the Baroness, pointing to a book in the bookcase. "It is Zola's *L'Oeuvre*. It deals with the failure of an Impressionist painter who loses his mind and commits suicide. Andries said that he and Vincent read it together."

"Did your husband describe the apartment in rue Lepic to you?"

"Oh yes, I remember he said the flat was quite large by Paris standards. But, after Vincent moved in, it began to look more like a paint shop than an apartment," said the Baroness. "Andries said that more than once he stepped out of bed in the morning into pots of colors that Vincent had left lying around. There was a woman living with them too."

"Did Theo and Vincent get along well together?"

"Theo was ill and Andries said that Vincent was totally inconsiderate of his brother's condition. They were both suffering from bouts of nervous depression but Theo was much worse. Vincent would come home late after drinking all night in the Café Tambourin with Toulouse-Lautrec and others and proceed to keep Theo awake by arguing with him in a very dogmatic way. He could be very objectionable, Andries said, and on one occasion in the Café Tambourin someone hit him over the head with one of his still lifes." I noted the name Café Tambourin, thinking of when I would be in Paris.

"Do you know what illness the brothers were suffering from?"

"No. Andries never said. He did say that he used to look forward to the days when Vincent would wander off into the country with his easel. He would get peace then.

"Vincent did have a sense of humor apparently, for when he returned from the country in the evening, Andries said that he would tell hilarious stories about his experiences with the villagers who thought he was a madman.

Andries and Vincent would roar with laughter as Vincent imitated their reactions to him.

"But these happy moments would not last. Within minutes Andries said that he and Vincent would be at each other's throats again. Vincent could never see anyone else's point of view, he said. When angry, he had an extraordinary way of pouring out sentences, in a wild mixture of Dutch, French and English—then glaring back over his shoulder and hissing through his teeth. . . ."

"And Theo?" I enquired.

" 'Poor Theo,' Andries used to say. He hardly had any clothes left to wear in his gallery. Vincent used them all up and just left them lying around mixed up with canvases and brushes. On one occasion he used one of Theo's clean socks to dry his brushes. You can imagine the effect Vincent's old underwear would have on Theo's business clients when he brought them back to his home."

I asked the Baroness about the relationship between the van Gogh brothers and the woman who was Theo's mistress.

"Andries hardly talked at all about this to me except for mentioning once that Theo had a lot of problems with a woman. But I saw from Andries' letters after he died that he referred to this woman simply as 'S.' I don't know why they wanted to conceal her identity. In his letters to Andries and Vincent, Theo also referred to her as 'S.' Whoever she was, Theo seemed to have a lot of problems with her. In letters, Andries described her as being rather highly strung, mentally unstable and also physically ill. Whether she was like that before she moved into rue Lepic or became that way after living with them, I really don't know."

I asked the Baroness if she learned anything about the relationship between the brothers and the woman called "S." She poured another cup of tea and continued.

"It sounded rather bizarre. 'S' was originally Theo's woman and I think they were living together when Vincent

landed on Theo's doorstep in the spring of '86. I am sure this is why Theo kept trying to dissuade Vincent from coming to Paris at that time. What happened after Vincent moved in I never really found out. But whatever it was, it finally made Theo leave the house. In his letters Theo made it clear that he wanted either Vincent or the girl to leave the flat.

"Apparently Vincent didn't approve of Theo's match. Vincent said he was scared that 'S' would commit suicide if Theo threatened to throw her out. But instead of offering to leave himself, he suggested to Theo that he take the girl off his brother's hands and marry her if necessary! Andries told both Vincent and Theo that he definitely did not think that was the best solution."

"What was the outcome?" I asked the Baroness.

"I never found that out. The girl was never referred to again in any letters that have been published. Theo ultimately went back to Paris and Andries left rue Lepic. He said that when he asked the brothers later what happened to her, the question was evaded by both Vincent and Theo."

I made notes for Paris: Who was "S"? What was Vincent's and Theo's disease?

The Baroness showed me around her garden, where I took some photographs of her. She said she enjoyed talking to me but didn't make a habit of dwelling in the past. She had never told anyone about it all before, mainly because no one had asked. Like Piet, she had been nearly forgotten by history.

Through two people I had spanned two years of Vincent's life. What a change seemed to have taken place in his character. Piet had seen him as kind and generous, Bonger as temperamental and inconsiderate. And this sense of change deepened the mystery for me. Through Piet and the Baroness I had seen him at two different points in his life. As I drove west, I wondered how and why had these

changes taken place. At this stage, of course, I didn't realize what the causes of this drastic change in Vincent's temperament were. I was intensely curious to find out, but that would have to wait. First I wanted to investigate an earlier period in Vincent's life—the two years he spent in London, where he first fell in love.

I had gathered that not much was known about his life in London, so a visit there would, I hoped, reveal more about him—if I could find people connected to him. Could there be any living links across the North Sea, I pondered. I drove through the darkness to Zeebrugge in Belgium and took the boat-train to Harwich. Vincent had made the same trip a hundred years before.

Chapter two
The Maynard Connection

Vincent was nineteen when he first crossed the North Sea to England. That was in 1872. For nearly four years he had been working as an apprentice art dealer with the firm of Goupil in The Hague. He had shown such promise—"Everyone likes to deal with Vincent," said his boss, Tersteeg—that it had been decided to transfer him to the firm's London office.

Vincent resigned himself to the move but showed an undercurrent of sadness at having to live so far away from home. As a postscript in a letter to Theo, who was also an apprentice art dealer at this time, Vincent advised him to smoke a pipe. "It's a good remedy for the depressions I have had recently."

In London Vincent gave an impression of middle-class respectability. He lodged with a family named Loyer in South London. He would walk every morning with jerky steps over Westminster Bridge, past the Houses of Parliament, to the Goupil gallery in Southampton Street, off the Strand. He dressed with top-hat ("You can't live in London without one," he said), rolled umbrella and stiff collar. The walk took him three quarters of an hour, and occasionally he would stop to make a sketch of something that caught his

eye. His mother wrote: "Now and then Vincent sends home a little drawing from his house and the street and from the interior of his room so that we can imagine how it looks. It is so well drawn."

Lonely and away from home, Vincent fell in love with his landlady's daughter. His feelings seemed to be intensified by the close relationship between the widowed Mrs. Loyer and her daughter. "I am happier than I have ever been," he wrote to one of his sisters, "I never saw or dreamed of anything like the love between her and her mother. Love her for my sake."

This girl, whom previous biographers have referred to as Ursula, was Vincent's first love. She rejected his advances and proposals of marriage, and turned him into a religious fanatic. His fanaticism set him on the path that would lead toward total devotion to art.

I was determined to find out more about this relationship. I also wanted to find out whether the house he had lived in was still standing. Did its present occupants know he had lived there? There was plenty to do in London.

But how to go about it? My only lead in London was Paul Chalcroft, the postman whose name had been given to me by Lily Couvée-Jampoller of the van Gogh Museum. She said that Chalcroft had been doing research on the London period of Vincent's life.

I had lived in London myself for five years in the '6os and knew the city well. I stayed with my old friends Jim and Nel Mailer at their home in Paddington.

Shortly after I arrived on September 17, I telephoned Chalcroft. It was a long and unexpectedly animated conversation. It revealed all of the man's warmth, enthusiasm and energy. Some of what he told me I already knew, but there were other things that made me want to investigate further. I arranged to meet him when he came off duty at Victoria sorting office.

I got to Victoria early and had to wait a few minutes.

When Paul finally emerged from behind a pile of mailbags, I saw a man with a kindly face, penetrating eyes and a sensitive mouth. With his deep forehead, cropped hair and goatee beard, he had the ingenuous air of an English Rousseau. Sitting down on a pile of mailbags, we talked. Or should I say, he did most of the talking. In ten minutes I had twenty pages of notes.

Paul's working life might not differ from that of any other London postman. His shift at Victoria is from 6 AM to 2 PM, and after work every day he cycles over the Thames to his home in Camberwell, south of the river. But after hours he is a dedicated and prolific painter, obsessed with Vincent van Gogh. Every day he transforms his kitchen table into an easel and paints for hours.

"I produce about 200 canvases a year," he said, "mostly copied from van Gogh postcards." He gives away most to friends and sells others for a few pounds apiece. And his fanaticism doesn't stop with painting. During the long post office strike of 1971, he decided to use his spare time to find out as much as he could about the Loyer family, whom Vincent lived with when he was in London.

Like me, Chalcroft had noticed that none of the books mentioned Vincent's address in London. He decided first of all to find out what it was, and thought he could do that by searching for the so-called Ursula Loyer.

Since Vincent was 20 in 1873, the girl would probably have been somewhere between 17 and 28, and was born therefore some time between 1845 and 1857. Chalcroft went to the national archives in Somerset House and began looking through every certificate of birth from 1845 onward. His search was slow and painstaking: for days on end he would pore over roll after roll of microfilm. Not until he reached the files for 1854 did he discover the only Loyer born in that region of England—on April 10, 1854, a girl named Eugénie Loyer at 2 Somerset Place, Stockwell. The father was Jean-Baptiste Loyer, described as a professor of

languages; the mother, Sarah Ursula Loyer.

"I was certain that this must be the girl, but although the age was right (she would have been 19 in 1873), the name was Eugénie and not Ursula, as the books on van Gogh all said."

Nevertheless, Eugénie's mother's second name was Ursula. Had historians muddled the names of mother and daughter? Had Vincent's mother confused the names? Or perhaps it was the landlady and not her daughter whom Vincent fell in love with.

Chalcroft knew that Eugénie said she was secretly engaged when Vincent proposed to her in 1873, but he didn't know if she ever married. He went back to Somerset House to find out. This time it took him months of searching through microfilm records to find what he was looking for. The man she married—on April 10, 1878, four years after she rejected Vincent—was Samuel Plowman, a twenty-six-year-old engineer. The couple were married at Lambeth Parish Church, and their address was given as Hackford Road, Lambeth, South London. Chalcroft showed me a copy of the marriage certificate. He also showed me a birth certificate: six months after Eugénie married Samuel Plowman, she had a son, Frank Eugene, born October 18, 1878. It looked like they married because of Eugénie's pregnancy, which must have raised a few eyebrows among the prudes of the parish.

Chalcroft had struck gold with this birth certificate, because now the address shown included house numbers as well as street names. The father's address was given as 17 Hackford Road and the baby was born at 87.

"I thought it strange at first," said Paul. "But then it occurred to me that Eugénie's mother could have lived at 87 and Eugénie returned there briefly to have her child."

If this supposition was correct—and Mrs. Loyer had lived at 87 Hackford Road in 1878—then Chalcroft might well have found the address he was looking for. But unless he

could establish that she lived there in 1873, when Vincent boarded with her, then the whole thing could be so much conjecture.

Before the final piece of the jigsaw could fall into place, Paul had to wait till January 2, 1972. On this date the detailed information became available of a census held 100 years earlier in 1871, only months before Vincent van Gogh moved to London. This would say exactly who was living at 87 Hackford Road.

"I went to the public records office on the first of January and asked to see the census return for 87 Hackford Road," said the postman. "You can imagine I was feeling a bit anxious. . . . These records were stored on microfilm, and when the relevant frame came into view I saw that there were only three occupants. Head of the household was Mrs. Sarah Ursula Loyer, a widow aged forty-six; the other occupants were her daughter, Eugénie Loyer, aged sixteen, and a boarder named Eleanor Tapp."

As far as Paul was concerned his search was over. He had satisfied his curiosity and that was enough. He didn't even make his discovery known to anyone but a few friends. This wasn't enough for me: I wanted to keep looking. With Paul's blessing I took up where he left off.

Paul told me that the house at 87 Hackford Road was still standing. He had passed it several times but "had never liked to knock at the door." I suggested that we go along together and talk to the present occupants.

"What, right now?"

"If not now, when?" I think I shocked him with my boldness, but he seemed pleased with the idea. He would never have gone on his own. So off we went.

The house at 87 Hackford Road is as anonymous as scores of other three-story Georgian terraced houses in South London. It stands at the end of a row and appeared narrowly to have escaped demolition in the 1960s, when the old houses on one side had made way for a housing

development. The name on the door was Smith. There was no one in when we first called.

As I was taking photographs of the house from the other side of the road, I could see neighbors' noses peeking out of the window curtains. I couldn't resist asking a passer-by if he had heard of a painter called Vincent van Gogh who was said to have lived on the street.

"Van 'oo d'ye sy?"

"Van Gogh," I repeated.

"Van Goff? Van Goff. Let me see now. A Dutchman, eh? No, mate.. Van Nobody like that livin' 'ere. You sure he's Dutch then? Not Pakistani?"

"No, no. This was 100 years ago," I said. "He was a Dutchman."

"Cor blimey, I'm not that bleedin' old. You from the police or somethin'?"

"No, I'm a journalist," I replied.

"Oh, one of them," he nodded. "Best of luck, mate. Hope you find 'im. Bye bye."

He scurried away and disappeared into a house down the road. I saw him take up a safe stance behind his lace curtains.

As Paul and I walked down Hackford Road, we spoke of a walk Vincent had made that ended in this same street. It had begun in Ramsgate, thirty miles away on the coast, and its object was to see Eugénie Loyer at number 87. This was after her disastrous rejection of him. We picked out which trees and houses Vincent might have seen when he walked here 100 years ago.

The next time we rang the doorbell, the door was opened by Mr. Smith, a man in his forties. We introduced ourselves and Paul quickly came to the point of our visit.

"The painter Vincent van Gogh lived in this house."

There was a brief pause, then Mr. Smith exclaimed, "Well I'll be blowed!" He was almost shaking with excitement, and it was a few moments before he invited us into

the house. There we met his wife Marjorie and son Mark, to whom he immediately told the news.

"Well I never," said Marjorie. "Vincent van Goff. I wonder which room he slept in? You know, our son Mark is an artist. He's involved in astrology you know, and makes all his paintings in his room upstairs. When we came here, it was known as the lodger's room. That would probably have been van Goff's room. My goodness, to think he lived here. Imagine, he'd have come down these stairs for his breakfast and sat here under this roof. Looked out of that window. . . ."

Vincent would not have recognized much of his old lodgings. The house was totally modernized and there were certainly no traces of Victoriana around. The Smiths assured me that they had found no traces of Vincent there. Since I was trying to keep the discovery secret for the moment, I asked them to keep it to themselves. They were happy to cooperate and liked the idea of being part of a secret, even if temporarily.

I took photographs of the house and of the Smiths together with Chalcroft outside, and then walked back with Paul to his home nearby. Over a cup of tea, he showed me yet another document. It was a copy of the death certificate of Frank Plowman, Eugénie's son, and it gave me my best lead for finding descendants.

The death certificate told me that Frank Plowman died in 1966 at the age of 87 and was buried at Biggin Hill cemetery, south of London. But most interesting to me was the signature on the bottom right-hand corner of the document. It was Kathleen E. Maynard, whom I assumed to be Frank Plowman's closest relative. Married daughter, perhaps. Did that "E" stand for Eugénie? Biggin Hill, 1966. Perhaps Kathleen Maynard lived there? There was only one way to find out.

But it was already 6:30 PM. And I was still at Paul's house. I decided to call it a day and save my next task—

calling every Maynard in South London—till the next day.

I drove up to the place where I was staying and told my friends everything I'd done that day. When I told them of my plan to call all the Maynards in South London, they looked at me a little strangely. They gently pointed out that there might be a hundred of them. I admit this hadn't occurred to me, but I was determined anyway.

After dinner I combed the London telephone book for Maynards but realized that Biggin Hill was outside the Greater London area. The telephone operator checked it for me and said there were over twenty registered in the Biggin Hill area. But no Kathleen E. That didn't worry me too much, as I expected that she would be listed under her husband's name anyway. Rather than ask an already harrassed operator to give me all the names and numbers, I went to the post office the next day and copied down the numbers myself.

I spent that evening on the telephone, introducing myself into different Maynard homes. I tried to keep the rather unusual story as simple and unsuspicious as possible.

First Maynard on the list was Albert. It was Mrs. Albert who answered. My introduction ran roughly like: "Good evening, Mrs. Maynard. I'm sorry to trouble you. My name is Kenneth Wilkie. I am working for a Dutch magazine called *Holland Herald* and am in London to research an article about the life of Vincent van Gogh, the painter. In connection with this, I am trying to trace a Kathleen Maynard who I think may have lived in the Biggin Hill area in 1966. . . ."

That was as far as I got.

"Oh, goodness me! And you think she may be living here! No, she's not living here. My name's Jemima and my husband, he's Albert. I don't think that there were any Kathleens in the family either. But I'll ask him. Can you hold the line a minute?"

Although Jemima had her hand held partly over the

receiver, I could hear most of what she was saying to her husband—mingled with bits of *Coronation Street* on the television.

"Albert!" she shouted.

"What is it then?" he growled back.

"There's a man on the phone, a painter called Henry Holland or something. He's looking for a Kathleen Maynard . . ."

"I don't know no Kathleen Maynards," I heard Albert reply. "Tell 'im to piss off. . . ."

" 'Em, hello . . . Mr. . . . em . . . Holland, was it?"

"Wilkie."

"Of course, Mr. Wilkie. I'm very bad on names. No, Albert says he's sorry but there's definitely no Kathleen Maynards in our family. I'm ever so sorry. I do hope you find her."

Not every Maynard was so helpful, or even superficially polite. Some didn't hide their distrust. A few inquiries never got further than: "You're wastin' your time here, mate. Nighty night."

After scoring the tenth Maynard off my list, I sensed a general nervousness amongst the Maynards I had spoken to. I realized why when Maynard number twelve, Mrs. Norman B., answered the phone.

After I had made my little announcement, she asked me to hold the line and I heard her, in a shaky voice, telling her husband: "Norm, there's a man on the phone asking for a girl called Kathleen. Oh dear, you don't think it could be that 'Beast of Biggin Hill' we were reading about in the paper the other day? They say he always phones before he strikes. . . . He assaults housewives sexually and he escaped a few days ago from the institution. . . . Oh dear. . . ."

Norman Maynard took the phone from his wife and said: "Now look here, I don't care who you say you are, we've had calls from the likes of you before. Now piss off before I get the police on yer track." The line went dead.

Something had obviously gone wrong with what I thought was my natural inquisitive innocence. I tried to pick my words to sound as unmenacing as possible. Still, no luck.

Maynard eleven: ". . . That's a Scottish accent. You're no Dutchman. You can't fool me. I was in Holland during the war."

Maynard twelve: ". . . Do I sound like Kathleen Maynard?" This voice was gruff and unmistakenly male.

Another Maynard, a spinster, I think, replied: "I'm sorry I can't help you, but it sounds so awfully exciting what you're doing. Would you like to come round for tea and tell me more about it . . . ?"

She obviously didn't care whether I was the Beast of Biggin Hill or not.

After the fifteenth futile call, I began to feel the irony of the situation. Here I was trying to find a descendant of the woman who rejected Vincent. So I had to be prepared to take a few rejections myself. But at the time it was plain depressing. I had also in the back of my mind the fact that I had other places to go in England—not to mention France, Belgium and Holland. My patience hadn't quite given out, but time was threatening. A week had already passed from my three-week schedule.

It was 11:30 PM. Both my ears had telephone tingle. I kept trying to convince myself that I was on the right line. I felt I had to follow this lead to its logical conclusion, even if it was a dead end. I kept thinking of the possibilities. If Kathleen Maynard, whoever she was, was related to Eugénie Loyer—perhaps a granddaughter—she might, just might, have photographs of her grandmother. And in that way the world would see for the first time what Vincent's first love looked like.

But I had doubts too. Perhaps I was approaching my research in the wrong way. Just because Kathleen Maynard signed the death certificate in Biggin Hill didn't mean she

lived there. She could be living anywhere in Britain—or Australia. As the hopelessness threatened to overwhelm me, I dismissed that possibility from my mind and plodded on. Finally, near the end of the Maynard file, it happened. A break.

At Maynard number nineteen, Mrs. Dorothy, the phone was answered by a pleasant-sounding woman. I gave the usual introduction, my tone so unbeastlike by this time I could have been the new village minister calling up his parishioners.

"Kathleen Maynard? No, not living here," she said politely.

"You don't have any relations in the family called Kathleen, do you?" I asked.

"Oh yes, as a matter of fact I do," said Dorothy. "I have a distant cousin, Kath. She stayed in Biggin Hill for many years till her father died. Then she moved away. That was a few years ago now."

"Did you know her father's name?" I asked.

"No, I can't recall his name."

"Do you know where she moved to?" I asked again, with clenched teeth. I was fully expecting her to say New Zealand or the Bahamas.

"Yes, down Devon way, I think. A village somewhere in the south of Devon." Not as far as I had thought.

"Do you have her address?"

"No. I'm afraid not."

"Was she married?"

"Oh yes, for many years."

"Do you know her husband's name?"

"Yes. Mort. That's short for Mortimer."

"Did they have a family?"

"Yes, a married daughter, Ann."

"Do you have Ann's address?"

"Oh, I'm not sure. I may just still have it. Could you hold the line a minute?"

The minutes seemed like hours as Dorothy Maynard looked for her old address book. There were beads of cold perspiration on my forehead and my hands felt clammy. This, I hoped, was the missing link in the Maynard chain. Dorothy came back to the phone.

"Hello! Are you still there?"

"Oh yes, yes!"

"Ann and her husband moved down to Devon near her mother. I've got her address. It's Ann Shaw, 4 Clay Park, Stoke Gabriel, near Totnes, South Devon, England."

"And her telephone number?" I was getting lazy.

"Totnes 035197."

I never did meet Dorothy Maynard, but at that point I could have given her a big hug. Though I was still not sure I had the right Kathleen Maynard, when I heard that this Kathleen's father had died in Biggin Hill a few years before, I felt very hopeful.

It was very late in the evening when I phoned Ann Shaw at her home in South Devon, but she was still up. After apologizing for my lateness, I explained who I was and why I was phoning her. Ann's tone of voice was suspicious at first. When I had gained her confidence a little, I began to ask a few personal questions.

"Is your mother Kathleen E. Maynard?" I asked.

"Yes, she is," replied Ann.

"Does the 'E' stand for Eugénie?" I couldn't resist jumping the gun and looked heavenwards while awaiting the reply.

"Yes. Yes, it is. How did you know that?"

"Was your grandfather a man named Frank Plowman who died in Biggin Hill in 1966?"

"Yes. Listen, just how in heaven's name do you know all this about our family? And what does this all mean?"

Trying not to sound like a detective and use phrases like "It's just part of my job, ma'am" and "I have reason to believe that . . . ," I told Ann that I had conclusive evidence

that there was a connection between her ancestors and Vincent van Gogh. I kept the specifics for Mrs. Maynard.

There was a pause and then Ann spoke again. "If you will hold the line a second I'll fetch a little silver snuff box I have on the mantlepiece. It belonged to my great grandfather and it has an inscription on it."

Ann brought the box to the telephone and slowly began to read.

"To . . . Jean . . ."

". . .—Baptiste Loyer?" I interjected.

"Yes. God, you know that too . . . 'as a token of regard on his leaving Stockwell Grammar School in July 1859.' "

I now knew beyond any doubt that this was the right family. I told Ann that I was very anxious to talk to her mother. As Mrs. Maynard didn't have a phone, I arranged to telephone her at her daughter's home first thing the following morning. I thought it wise not to tell all at this stage. Next morning at 9 AM I talked to Kathleen Maynard, Eugénie Loyer's granddaughter. She sounded a little nervous, which was understandable, but even more curious. I did my best to contain my own curiosity for a moment and reassured her that there was nothing sordid or scandalous about my call, that I did not belong to the muckraking breed of journalist. She confirmed that her name was Kathleen Eugénie Maynard, and that she had buried her father at Biggin Hill in 1966, and that her grandmother was Eugénie Loyer. I took a deep breath and said:

"Did you know that Vincent van Gogh, the painter, lodged with your great-grandmother, Mrs. Ursula Loyer, at 87 Hackford Road in South London?"

I heard her catch her breath.

"No, no. I didn't know anything about that. Good heavens!" replied Mrs. Maynard.

"And did you know that Vincent fell in love with your grandmother when she was in her late teens?"

"You must be kidding . . ."

"And that she rejected him, and this rejection set him on the path to religious fanaticism."

She was breathless. "Oh, this is all too much. I knew absolutely none of this. I remember seeing the film with Kirk Douglas in it and I remember the episode with the girl in London. But to think that was Granny. . . . Oh, it's really all a bit much to take in. . . . How did you find all this out?"

"It's a long story, Mrs. Maynard, but I'll be glad to tell you. I wonder, do you by any chance have any photographs of your grandmother Eugénie?"

"As a matter of fact, I think I may well have. Dad's hobby was photography and he took a lot of photographs of the family around the turn of the century. I think there are quite a few in the attic, but I'll have to look them out of course and there's so much rubbish up there. . . ."

By this time I was so excited I was fumbling for words. I asked Mrs. Maynard if I could visit her that day and look through whatever photos she had.

"It's a long way from London, you know," she said. "The other side of England. But you are very welcome to come and have a look."

I was all for taking off the next minute, but Mrs. Maynard asked if she could have a day to sift through her "rubbish." She asked if I would phone her back at her daughter's that evening and by then she would have a clearer idea of what was in the attic. I agreed, preparing myself for a day of suspense. I knew I was going to have trouble keeping my mind off the contents of Mrs. Maynard's attic.

I still had other places to go for my assignment, and thought that a visit to one of them would force me not to think about Devon all day. I chose Welwyn, thirty miles north of London, where Vincent's sister Anna had worked as a teacher. Vincent had walked all the way from London to visit her there.

Anna had lived in a house called Ivy Cottage, which still stands today. Its occupant is an elderly lady by the name of Freda Davis. She lives there alone and takes a keen interest in the house's history. She often sees Vincent's ghost at nights, and says he is "always making a consoling gesture as if to pass on the same consolation he himself had received under this roof from his sister Anna when he was grieving over Eugénie. Everyone comes here for consolation."

I thought that I might be in need of consolation myself if Mrs. Maynard had lost that photograph of her grandmother she thought she had. Much as I tried to concentrate on Mrs. Davis' strange tales, as I sat in the dark drawing room my mind kept drifting off down to Devon.

Mrs. Davis showed me a little butter dish that she said Vincent's sister had received from Holland as a birthday present. After taking photographs of her and Ivy Cottage, I politely took my leave and drove up the Thames to Isleworth, the village where Vincent preached his first sermon. I photographed the house where he lived and the church where he preached. All part of the assignment, but my heart wasn't in it.

That evening I called Mrs. Maynard at the appointed hour and just let her talk. . . .

"Well, I had a look through the attic and I've found one or two pictures of Grandma, one when she was quite young, in her late teens or early twenties, I should say. And there are a lot of other photographs Dad made of the family. But I shouldn't think you'll be interested in these. A lot of them are on old glass negatives."

I told Mrs. Maynard that, on the contrary, any photographs of Eugénie and her family and of Hackford Road were of great interest indeed. I arranged to visit her the next day. It's impossible to convey the excitement I felt, knowing that the next day I would be looking at a previously unknown photograph of the girl who had changed Vincent's life.

That evening I gave my editor Vernon Leonard a ring at his home in Chislehurst. I wanted to explain about Chalcroft, Hackford Road, Mrs. Maynard, and my proposed journey to Devon. I also wanted to share some of my excitement. But his reaction surprised me. He said that in view of the little time left and the large areas yet to cover on the Continent, I was plain crazy to go all the way down to Devon. He suggested I ask Mrs. Maynard to send a photograph of herself and one of her grandmother to the office. I told him I felt Mrs. Maynard might not know the significance of what she had down there and that I was absolutely convinced a visit would be worth it. It was the end of a logical trail. He reminded me that my deadline for research was absolute, that I still had many places to visit, and that I was expected back in the office on the appointed Monday morning, October 2nd. But since a condition of the assignment was that I use the allotted time as I thought fit, Leonard reluctantly agreed.

Early next morning I drove out of London, bound for South Devon. I followed the main road west through the counties of Hampshire and Somerset and at Exeter branched south to Newton Abbot. Bypassing Dartmoor, I followed the little country roads through the rolling land of South Devon. The hedgerows and trees were mellowing into their rich autumn tones. My excitement seemed to heighten my perception of the landscape's beauty.

One of the narrow roads wound into the village of Stoke Gabriel, a community of cottages that staggered down to an estuary. "Greenways," where the Maynards lived, was a bungalow on the outskirts of the village with a large, beautifully kept front lawn. An unlikely place to be tracking down van Gogh, I thought to myself as I walked up the pansy-lined garden path. Kathleen Maynard and her husband Mort greeted me at the door. Their manner was unassuming but very friendly, and immediately hospitable.

"You must be hungry after that long journey," said Mrs.

Maynard. Over tea and sandwiches, I told her in more detail about the assignment and the events that led me into her living room . . . about the relationship between her grandmother Eugénie and Vincent. How this woman affected him so deeply that he is said to have walked the seventy miles from Ramsgate, where he was teaching, to London—only to catch a glimpse of her. How if she had accepted his proposal of marriage, he might have become a part of London middle-class society instead of immersing himself in the Bible, devoting himself to his fellow men and finally his painting.

As we talked, I could see out of the corner of my eye two long wooden boxes, like sections of an old library index file, sitting on the sideboard. Protruding from these boxes were bits of grease-proof paper that were used to protect glass negatives. And beside the wooden boxes was an old cardboard box.

"Well, you must be very curious to see Eugénie," said Mrs. Maynard. She probably noticed the distracted way I was nibbling at my egg and tomato sandwich.

She walked over to the sideboard and brought the boxes to the table.

"I spent all day in the attic yesterday," she said, "and have brought down everything in the way of photographs that was up there."

"The wooden boxes are full of glass negatives. Most of them were taken by Dad and some I think by Granddad. I honestly didn't know what to do with them all when Dad died. He was one of these people who kept everything, you know. And I suppose that's one of the things I've inherited from him. . . ."

Mrs. Maynard dipped first into the cardboard box and brought out a little faded photograph. "That's Granny when she was young," said Mrs. Maynard.

And there she was. Eugénie Loyer in her late teens or early twenties looking as she did when Vincent proposed

to her—head cocked slightly, a straight, rather hard mouth, penetrating eyes, dark hair parted in the center and hanging in long curls from the sides, a white bow around her neck and lace collar over her shoulders. With a rather stern disposition, even allowing for the long exposure, it was not difficult to imagine her saying "No!" to the passionate young Dutchman.

Mrs. Maynard then showed a larger photograph made of Eugénie a little later in life when she was running a school, looking very much the part of a strict school teacher. To show Eugénie much later with her husband and family, Mrs. Maynard went to the boxes of glass negatives. We had to hold them up to the light in order to see them. There was Eugénie—sipping tea in the garden with husband and family, at the beach with the family and with her pupils. Most of these fragile negatives were taken by Mrs. Maynard's father, Frank Plowman, and Eugénie's daughters, Kathleen, Eugénie (called Dolly), Irene and Enid, were in most of them. "Aunt Enid is still living in Wimbledon," said Mrs. Maynard. (Next stop Aunt Enid, I thought. I hoped she would be able to tell me about her mother.)

We looked through the negatives and prints one after the other. But one of the negatives particularly interested me. It showed the interior of an upstairs room in Hackford Road and, according to the date on the back of it, it was taken at the time Vincent was living there. This was incredible. I recognized the room, as I had been in it a couple of days before. We examined the negative closely and saw a pipe in an ashtray on the mantlepiece, clothes draped over a chair, porcelain wash basin and jug. I suggested to Mrs. Maynard that the pipe and clothes were probably Vincent's. We looked closely at the negative but could find no other traces of him. It was an eerie feeling to be confronted with this simple photographic glimpse into his life 100 years ago.

I kept aside the prints and negatives I had particular

49

interest in—mainly those of Eugénie and her family.

Mrs. Maynard had made a preliminary sift through the contents of the cardboard box of prints and had already picked Eugénie out of the assortment. She was about to put the box away when I asked her if I could have a look through it myself. As I had come all this way, I was eager to see everything.

"Go ahead," said Mrs. Maynard. "But I don't think you'll find anything else of particular interest. There are mainly snapshots."

Snapshots there were, piles of them. The family on holiday. Frank Plowman—he was an inventor as well as an engineer and a photographer—on his home-made motorcycle. Mrs. Maynard as a pretty little girl picking daisies in a Biggin Hill meadow. More of Frank Plowman—this time with a home-made motorized tricycle-built-for-two that surely belonged in the Museum of Natural History. All fascinating in their own right.

But what I saw next, lying in the very bottom of the box, went beyond the realms of fascination.

It was a little drawing, unsigned and stained with what looked like tea or coffee. It was soiled with age and a little frayed at the edges.

I felt an army of caterpillars run up my spine as I realized what I was looking at. It was the house at 87 Hackford Road—drawn from the same angle that I had photographed it a couple of days before.

"Do you know what this is?" I asked Mrs. Maynard.

"That drawing? No, I don't know where it's meant to be exactly. I remember Dad saying something about it once but I can't remember what. It's been up in the attic for as long as I can remember."

"That's 87 Hackford Road," I said. There was a long silence. I looked at the drawing but said nothing. I didn't have to be an art expert to see that this drawing could be 100 years old. From his mother's letters, I knew Vincent

had the habit of drawing the houses where he lived. And what could have been more characteristic of the love-sick Vincent than to give his beloved Eugénie a drawing of their home in Hackford Road? Experience has taught me never to jump to conclusions. But this was one conclusion I couldn't resist.

I looked at Mrs. Maynard and said: "I think that Vincent probably drew this for your grandmother Eugénie." I said it as casually as possible, hoping she wouldn't faint. There was another long silence. I thought I might faint myself.

"I . . . I suppose he could have," she said. Her hand made for the teapot.

Like cats around a goldfish bowl, we pored over the little drawing. "We'd better be careful—it's not used to all this attention," I said. We laughed nervously.

One thing struck me as odd. Today 86 Hackford Road is a corner house. In the drawing it was the fourth house from the corner. Then I remembered there were new houses adjacent to it today. With the aid of a magnifying glass, I saw that the artist had written the name Hackford Road on the drawing. "Christ, he's even written the street name in," I said, already imagining Vincent van Gogh as the artist.

Another nameplate said Russel Street. From a map of London I had with me in the car, I saw that Russel Street no longer exists. But, uncannily appropriate to the occasion, there was an old map of South London also in the cardboard box. And this map showed, indeed, that Russel Street was originally adjacent to Hackford Road.

I eagerly scoured the drawing for traces of van Gogh, although I knew that at the age of nineteen he hadn't begun to develop any distinctive style. The cardboard on which the drawing was made appeared to have been prepared and heightened here and there with white.

I asked Mrs. Maynard if I could take the drawing back to Amsterdam with me where I would have it examined by

an art expert. She agreed and also lent me the photos and negatives I required.

Over a glass of sherry, we indulged in a little speculation. Mrs. Maynard racked her memory for stories related to the drawing but couldn't come up with anything. It all seemed too incredible to be true and we all tried not to jump to conclusions. Mrs. Maynard agreed not to discuss the story with anyone except her daughter Ann.

As the light was already fading, we went into the garden where I took some photographs of Mrs. Maynard with the silver snuff box that had been presented to her great-grandfather Loyer in 1859.

It was nearly 7 PM when I left Gabriel to drive back to London—the little drawing, the photographs and the glass negatives all hidden away. In our enthusiasm and excitement, neither the Maynards nor myself had thought about anything as official as a receipt. We had a mutual trust that meant more than slips of paper.

The seven-hour drive back to London seemed to pass quickly in the excitement. No matter how skeptical I tried to be, I just couldn't keep down the overwhelming feeling that Vincent made this drawing. Occasionally I would stop the car and look at it again, almost disbelieving how I had come across it. But I realized that there was a very long way indeed between personal conviction and an expert's testimony.

And it was a long way I still had to go on the van Gogh trail too—drawing or no drawing. I couldn't let these finds take up much more of my time. My fear was that I might lose the drawing in an Arlesian absinthe den or down a mine in the Borinage or in the mental hospital at Saint-Remy. I suppose some people would have gone straight to a bank with the goods I was carrying. Not me. Of course, I wanted to show it to Dr. Tralbaut if I met up with him in Provence. But the truth is mainly that I just didn't feel like parting with it, the little treasure I thought

it could be. It didn't look like it belonged in a bank. And I had worked in a bank myself once. . . .

But before I left England, there was one person I had to look up—Eugénie's only surviving daughter, Enid Dove-Meadows. Having arrived back in London about 3 AM, I was up first thing next morning and on the road to Wimbledon.

Fortunately, Enid was at home. She was a spry old lady of 84 with a direct manner and a buoyant sense of humor. She could hardly believe it when I told her the story. When shown the photographs I had of her mother, Enid exclaimed: "Oh yes, that's her all right, who could forget a face like that? I don't think age improved her, do you?"

"I knew nothing at all about Mother's affair with van Gogh. Good gracious, it's hard to imagine. Mother was certainly not the sort of person to divulge secrets—least of all to her own family." I asked Enid about her mother's character. Though she had no photos or drawings, she had a vivid memory and sharp wit.

"Even by Victorian schoolmistress standards Mother was a severe woman," said Enid. "She was extremely strict—but you wouldn't say unkind. There was certainly no playing around with her, although it's possible that Vincent found it otherwise. She would not express her feelings very often and it was often difficult to guess what she was thinking. But when she did let go, she would fairly explode.

"Grandma [Mrs. Ursula Loyer, Vincent's landlady] was more lenient. She was a kindly old soul and had more warmth about her altogether than Mother. I could imagine that she would have been a very hospitable landlady to Vincent."

Enid recalled how on Saturday nights, when her mother and father went to the theater, Grandma Loyer and her grandchildren would gather round the fire and tell stories to each other. "Grandma always insisted on the maid being there too," recalls Enid. "She was a Welsh lass. But

when Mother returned from the theater and caught us all still up she would order the maid from the room and scold us for disobedience. Grandma would protest, but Eugénie ruled the roost. And she could henpeck Father from morning to night too. He was rather passive. My goodness, I wonder what Mother would have thought of my great love in life today—dog racing? I work at the stadium nearby on the odd evening. The more I think about it, perhaps it's just as well for Vincent that she didn't agree to marry him. Don't you think?"

On the basis of what I had heard, I heartily agreed with Aunt Enid. A few years after his London period, Vincent would be reported as sharing his last crust of bread with a hungry dog. How ironic that he had been driven to such altruistic limits initially because he had been rejected in love by a prude who treated her maid as an inferior being. It was difficult to envisage the compassionate Vincent van Gogh bringing up a family with a haughty woman like Eugénie appeared to be. Nevertheless, that had been his intention in 1873.

Suffering had a profound effect on Vincent. It made him sensitive to the pain of others and intolerant of materialistic values. The assiduous young salesman was now telling customers at the Goupil gallery what he really thought about some of the paintings for sale and didn't care if they didn't buy. The management transferred him to their Paris office but he couldn't keep his mind off Eugénie and, after two months, went back to London and took a room (in a house now demolished) near the Loyers. After what appeared to be a final refusal from Eugénie, Vincent returned to his parents, who had moved to Etten in the south of Holland. He was fired from Goupil's.

But still he couldn't forget Eugénie and was soon back in England—at Ramsgate, on the Kent coast, where he had found a job as an unpaid teacher. Then, after a few months, the unsettled Vincent left his job in Ramsgate and went to

Isleworth, the village I had already been to.

Apart from preaching and teaching, his job also entailed collecting school fees from parents in the poor East End of London. Here Vincent came face-to-face with human suffering that increased his desire only to help his fellow men and not to take their money. He made one last pilgrimage to the Maison Loyer at 87 Hackford Road, on the day after Mrs. Loyer's birthday. Whether he saw Eugénie then is not known, but he finally left England and crossed the North Sea for the last time.

I had spent long enough in England myself by this time. It was September 23. I had used up more than half of my research time already, and I had many places to visit before I returned to Amsterdam. There was no time to delve further into his life in London. I had enough on my plate as it was. Belgium and France lay ahead, and already it was going to be a race against time. So I decided to save time by traveling as much as I could during the night.

Armed with photographs and drawing, I took the night boat to Belgium. I kept my new-found material in a hard cardboard envelope and kept it with me always, whether walking on deck or going to the toilet.

From now on the drawing and I would be inseparable.

The boat docked before dawn, and I headed south in the darkness to the Belgian "Black Country," wondering if there was anyone in the mines who could cast any light on Vincent.

To say I was glad I had gone to England was an understatement. But not only had I found more than I had ever bargained for, I believed I had gained an insight into the evolution of Vincent's character. By following his life in such an unusually close way, I was able to feel the change that was going on inside him.

Chapter three
The Christ
of the Coalmine

On the boat to Belgium, I traced Vincent's movements after
he left England in a depressed state. Before becoming a
missionary to the poor miners of Belgium, he had a spell as
bookseller's clerk in Dordrecht, near Rotterdam, and as a
student of theology in Amsterdam. These were brief
periods and well documented by his friends at that time.

In Dordrecht Vincent shared a room with a young
teacher named Görlitz. Görlitz told of his already eccentric
behavior: "Vincent said lengthy prayers and ate sparingly
like a penitent friar. In the evenings, he changed into a
blue peasant's smock and spent the night translating the
Bible into four parallel columns of French, German,
English and Dutch—while also writing sermons. On
Sundays he attended three or four religious services." It
was Görlitz who recalled that even when Vincent didn't
have enough money to buy himself half an ounce of tobacco,
he would spend his last cents to buy a roll for a hungry dog.

Vincent resolved to become a minister like his father and
left Dordrecht for Amsterdam to study theology under a
young professor of classics named Mendes da Costa. They
became friends and da Costa left a poignant description of
Vincent in his days as a Greek and Latin scholar: "I can

still see him stepping across the square from the Nieuwe Herengracht bridge, without an overcoat as additional chastisement, his books under his right arm, pressed firmly against his body, and his left hand clasping a bunch of snowdrops to his breast, his head thrust forward a little to the right, and on his face . . . a pervading expression of indescribable sadness and despair. . . . And when he had come upstairs, there would sound again that singular, profoundly melancholy deep voice: 'Don't be mad at me, Mendes, I have brought you some little flowers again because you are so good to me. . . .' "

Vincent had great difficulty in coping with formal scholastic work. "Mendes," he would say, "do you seriously believe that such horrors as Latin and Greek are indispensable to a man who wants to do what I want to do—give peace to poor creatures and reconcile them to their existence here on earth?"

The teacher knew in his heart that Vincent was right and wasn't surprised when, in July, 1878, young van Gogh gave up his studies and took a three-month crash course at a school for missionaries in Belgium. Because of his erratic behavior, he failed the course; but in the end he was given a trial term as an evangelist in a poor village called Petit Wasmes in the French-speaking Belgian "Black Country," the Borinage. There people worked in satanic mines under a yellow-gray sky perpetually foul with fumes and smoke.

I had decided to head straight from the boat for the Borinage. It was in this miserable mining land that Vincent reached extremes of self-sacrifice for his fellow creatures. And apart from the restrictions of time, I felt that there was more likelihood of finding human links in a small community like Petit Wasmes, where the pattern of life has more continuity from generation to generation, than in the cities of Amsterdam and Dordrecht. Perhaps the deeds of this extraordinary missionary had not passed totally beyond the reach of human memory.

I had a few basic facts to go on. Vincent had lived with Jean-Baptiste Denis, a baker, and his wife Esther, in their home at 22 rue de Wilson. Vincent would go from there down the 2,000-foot shaft of the notorious Marcasse mine to preach the word of God to the miners—women and children among them—literally on their own level.

My boat arrived at Zeebrugge, Belgium, before dawn on Sunday, September 24. It was a clear day and in spite of my tiredness—I had slept little on the boat—I felt elated. My trip was turning up far more than I had ever expected: old memories, photographs, the drawing. . . . Some of that self-importance I had felt when driving to see Baroness Bonger returned. Even if I didn't take it too seriously, I didn't fight it too hard—it kept me awake and alert for the hour drive from Zeebrugge to Petit Wasmes.

The Borinage lived up to Vincent's descriptions of the place. The landscape was dreary, barren and forbidding. Dead trees blackened by smoke stood like permanent scars on the earth's face. The only living vegetation seemed to be thorn hedges. Ash dumps and heaps of useless coal littered the scene. And from every vantage point one's view was dominated by the abandoned mines. Not even the friendly sunshine could change the impression that this was indeed the "Black Country."

The first folk were already on the streets when I arrived. Hob-nailed boots clattered loudly on the cobblestones, drowning out what little conversation there was between the miners on their way to work. The people I saw were squat and strong, but their faces looked thin and unhealthy. The women especially—I suppose I looked at them more closely than at the men—looked emaciated and faded before their time. They reminded me of the little gnarled heavy-boned figures in Breughel's paintings. Their postures bore all the marks of long hard work under the earth. The French these Belgians spoke was a thick patois that sounded as if their throats were clogged with coal dust.

I went into a baker's shop and bought two croissants. The shopkeeper was an elderly woman and I asked her if she knew of the old baker called Jean-Baptiste Denis, who had lived at 22 rue de Wilson many years ago.

She thought for a few moments before answering. "Denis . . . Denis . . . oh, yes, when I was a little girl I used to buy bread for the family from him. He was a little old man with a long white beard and always used to give me a cake on Saturdays. He died a long time ago. My father worked for him when he was a boy. But Papa, too, has been dead for many years," she said.

The lady didn't know any legends about a Dutch missionary who stayed in Petit Wasmes in the 1870s, but she directed me to rue de Wilson.

"You see that mine shaft and slag heap over there? Well, rue de Wilson is up that hill." Her voice became quieter. "That mine is called the Marcasse. It's closed now. And a good thing too. There were so many disasters. Two of my uncles died in the Marcasse. I am sure that there is hardly a family in Petit Wasmes who hasn't lost a relative there."

Number 22 rue de Wilson was at the end of a row of nearly identical two-story houses. It looked spotlessly clean. The windows were gleaming in the early morning sun, as if the occupants had made sure that the cleanliness of their home compensated for the grime of the pit.

I knocked twice and the door opened abruptly. A tall man with a strong proud chin and straight silver hair stood in the doorway. He held himself up erect, a rather stern, almost aloof expression on his lined face.

I explained my mission—in French this time. Kathleen Maynard was already a memory at the other side of the North Sea. I told the man I was looking for descendants of Jean-Baptiste Denis, the baker who once lived at this address.

"You need look no further," said the man in a thick accent. "My name is Jean Richez. I am the nephew of

Jean-Baptiste Denis. I was named after him. Come in. You have come far from England. Sit down."

What luck, I thought to myself. The door opened into a spacious tiled room that served as both kitchen and living room. It did not look as if it had changed much since Vincent's day. Some bread and cheese lay on the scrubbed wooden table in the middle of the room. A wooden rocking-chair sat beside the open hearth.

Richez offered me a glass of dark Belgian beer and we sat down at the table. After a few slow sips, he began to tell me about his uncle the baker.

"Uncle Jean died in 1934. He was eighty-four. And till the day he died he made the best *baguettes* in the Borinage. As far back as I can remember, I spent my holidays in this house with Uncle Jean and Aunt Esther."

"And did they ever say anything about the painter van Gogh?"

"Oh yes. They often talked to me about their strange lodger Monsieur van Gogh. He seemed to be a very un-usual man. They told me that he insisted on sleeping like a beast in a little hut—like the one you see out there."

I looked out of the window. A tumble-down shack stood at the end of the narrow garden that tapered away into the mine-ravaged land beyond. Not far off were the black pyramids of waste that towered over Pit Number 7, the Marcasse that Vincent knew so well.

"When Aunt Esther asked Monsieur van Gogh why he insisted on sacrificing his room upstairs in favor of that hovel outside, he replied: 'Esther, one should do like the good God. From time to time one should go and live among His own. . . .' Aunt Esther reprimanded Monsieur van Gogh for rushing out every morning to visit the poor, without spending time to wash or do up his laces. To this, Monsieur van Gogh's reply was 'Esther, don't worry about such details, they don't matter in Heaven. . . .' "

Having arrived at the stage where he had no shirt or

socks, Vincent is said to have made shirts out of sacking.

"Monsieur van Gogh would quite often hold improvised services for the miners—in a hut, in the street, or actually down the mine shaft—dressed in nothing but an old sack. Aunt Esther used to say she wished there had been more men around like Monsieur van Gogh. She told me he often did the washing to help some of the local women. My wife is certain that no man before or since has done that here in the Borinage."

I asked Richez if Vincent had left behind any drawings of Borinage life. "Uncle Jean told me that when he was baking bread for the following day, Monsieur van Gogh would sit and quietly draw him at work. Unfortunately, I have no idea what happened to these drawings. Knowing Aunt Esther, she probably threw them out. She left nothing lying around the house. She was so tidy she used to make the sun wipe its shoes before it was allowed to shine through the windows in the morning. No, there is no attic here and there are certainly no drawings or paintings in this house . . . if that is why you are looking around the walls!" Without even being aware of it, I was doing just that, but the only piece of art was a little wooden statue of the Virgin Mary hanging in a corner of the kitchen.

As Richez reminisced, it became apparent that Vincent's charity was not confined to mankind in these dark religious days.

"Aunt Esther said she remembered how Monsieur van Gogh would pick up caterpillars and put them back on branches. He would even put cheese and milk outside for the mice—one mouse he called Vincent and the other a girl's name. No, my aunt didn't tell me the other name. This was while he was living on bread and water himself, mind you. People treated him like a madman in the village, but they loved him just the same, so my aunt, used to say."

While Vincent was in the Borinage, there was a series of fire-damp explosions. And Richez remembered his uncle

telling him that the Dutchman worked frantically for days and nights on end to help the injured miners—tearing his remaining linen into bandages and steeping them in olive oil and wax to treat the miners' burns.

"Aunt Esther said she used to hear Monsieur van Gogh crying all night in his hut outside. He made a very deep impression on her. None of the miners who knew him ever forgot the man they called the Christ of the Coalmine."

Noticing how I kept looking out of the window that framed the pithead of the Marcasse mine, Richez said: "You seem interested. I will take you to it." We finished our beer and walked out into the dreary cobbled street that led to the mine. It had developed into a gray, lightless day. Apparently the sun had given up. Did it feel out of place here?

Richez walked with hands clasped behind his back and an erect gait. He never smiled and rarely altered his fixed, stern expression.

"After the last disaster in 1960, the Marcasse was closed," said Richez, pointing to the shaft. "You see it is filled with concrete. If the mining company hadn't closed it, I am sure the miners would have done it themselves. It was a killer."

Richez stared thoughtfully at the ground. He told me that two of his own family had died in the Marcasse and he himself had narrowly escaped with his life before he was pensioned off.

Under the rusty girders there were still stables with straw waiting for the pit ponies. Among the rubble lay a rusty miner's helmet, half buried in the black earth, an eerie reminder of the men, women and children who never came up. The word Marcasse is still met with disquieting looks from the local people. "The mine is closed," said Richez, "but its memory will always remain in the minds of the people of Petit Wasmes."

Richez didn't talk much in the Marcasse. There was no

need. The long heavy silences said everything that could possibly be said.

I felt that so much of Vincent's life must have been dominated by darkness. But he would have been too proud to give in to feelings of fear. Indeed, it was this darkness that Vincent went down the mine to find. Through religion he had tried to bring light into the lives of these poor miners. Instead, he had plunged himself into a deeper darkness of disillusionment. The only light that fired him in the Borinage was the eerie pale reflection on the miner's faces as they sweated in the labyrinths of the Marcasse. It was this light that he would recreate in his first masterpiece, painted a few years later, called *The Potato Eaters.*

Coming out of the mineshaft into the dull gray afternoon light, both Richez and I remained silent. I imagined Vincent's reaction to the suffering he must have seen in that awful place. Going there today was chilling enough.

We walked back to Richez's house, where I took my leave of him and his wife. They stood in front of the place as I drove off. Something in their stance suggested indomitable pride, a refusal to give in to the forbidding land where they made their home. I thought of them as I drove to the nearby village of Cuesmes, where Vincent lived after leaving Petit Wasmes. He had walked there, half-starved, and lodged with a miner called Decrucq and his family.

As in Petit Wasmes, Vincent discovered that men, women and children were working like slaves twelves hours a day. He became furious when he found out how the mine bosses operated. Out of every 100 francs of net receipts, they paid only 60.9 in wages and turned over 39.1 to the shareholders.

Characteristically, Vincent took on the capitalist machine single-handed. He went to the mine bosses and demanded a fairer share for workers. In return he received insults and the threat of being shut up in an asylum.

Vincent now abandoned all hope of following his father's footsteps through religion and was on the point of following his mother's—into art. For even in the most unlikely situations in the Borinage, he would always find time to draw the miners plodding their weary way to and from the pit. In fact, he wrote to Theo at this time that his devotion to Rembrandt was as sincere as his devotion to Christ. Drawing, he said, liberated him. And he had begun to make copies after Millet, the French painter of laborers.

I had no better luck in Cuesmes than Vincent had had. An old miner, sitting at his doorstep, directed me to the Decrucq cottage: It was a roofless ruin, listing to one side, and sinking into a marsh. Ghosts would have been all that I could possibly find there.

Not surprisingly, there were no hotels in Cuesmes, so I planned to spend the night in my sleeping bag, parked near the ruined miner's cottage where Vincent himself had stayed for a few nights. Where did he go next? I traced his movements in my mind as darkness set in. From the Borinage he went to the art academy in Brussels, but right away found it too expensive and returned to his parents' home at Etten.

This was in April of 1881. The spring began peacefully enough till Vincent's cousin Kee Vos and her little son came to stay with the van Goghs for the summer. Kee Vos's husband had just died and Vincent felt a sympathy for her that developed into a deep passion—a feeling that had been smoldering in him since his unsuccessful love affair with Eugénie Loyer in London.

Till now, he admitted to Theo, he had been living in the emotional wake of Eugénie's refusal. And his cousin Kee seemed to appeal to his peculiar combination of sexual need and human compassion. But when he declared his love, she, too, firmly rejected him. She left immediately for Amsterdam and Vincent was in torment. He bombarded her with letters that she apparently refused to read. Theo

even gave him money to go to Amsterdam to meet her, but she refused to see him. "Kee left the house as soon as she heard you were at the front door," said his uncle at the doorstep of Keizersgracht 453. Vincent was admitted to the parlor and was convinced Kee was still in the house. There followed the scene (made famous in *Lust For Life*) where Vincent held his hand above the flame of an oil lamp, insisting he would keep it there for as long as he could not see Kee. But Pastor Stricker blew the lamp out and told his eccentric nephew to leave the house. The disillusioned Vincent headed for home again with his tail between his legs.

On Christmas Day, 1881, things came to a head at Etten when Vincent and his father had a violent quarrel, mainly over Vincent's refusal to attend church. The Reverend told his son to get out within the hour and Vincent took the train to The Hague to take lessons with the painter Anton Mauve.

While there, Vincent's thoughts turned away from religion. He wrote to Theo: "I am a man and a man with passions, I must go to a woman, otherwise I shall freeze or turn to stone. . . ."

The woman he found was a prostitute called Clasina Maria Hoornik. Vincent seemed to be attracted to this woman, not only to satisfy his lust, but because she represented the same kind of poverty and misery that he had tried to alleviate in the Borinage and depict in his art since then. Not long after meeting Clasina, he set up home with her and her daughter Maria. Vincent spent several weeks in the hospital being treated for gonorrhoea and Clasina bore another child, Willem, several months after they had been living with each other.

Vincent didn't tell Theo about his new model till many months after he had been living with her. When he began to talk of marrying her, Vincent's father contemplated having his son confined in a mental asylum at Gheel in

Belgium. Instead, the family threatened to withdraw Vincent's allowance unless he left her: he was faced with the choice between losing Clasina and losing his sole means of support. Unwillingly, he chose the former.

In reviewing Vincent's Hague period, I had a vague feeling that there was still something to be learned about it. I remembered noticing back in the van Gogh Museum archives in Amsterdam that parts of some letters from this period were missing and there were deletions in others.

Was someone hiding these letters from public view? If they were, why? What possible motive could there be for censoring the letters of a painter? Governmental documents, certainly—but harmless old van Gogh, an artist long dead? It seemed absurd, yet there it was. . . . Clasina of course was dead—she drowned herself about ten years after Vincent's death—but what became of baby Willem? I did a little calculation and figured that if he were still alive he would be about ninety—no older than Piet van Hoorn, who had collected bird's nests for Vincent in Nuenen. Was Willem still alive? Did he know of his background? I wanted to find answers to these questions.

But to do so I would need time—time for research in archives, time to follow God knows how many blind alleys.

Getting my map and flashlight out of the car, I assessed my position. Basically I was sitting in a marsh in the south of Belgium. In a week I had to be back in Amsterdam with the makings of a story in my notebook. I still had Arles, Saint Remy, Paris and Auvers-sur-Oise to visit. There was also Dr. Tralbaut, in the south of France, whom I wanted to talk to. The distance to be covered was over 800 miles as the crow flies—not allowing for diversions of any kind. I got out of my sleeping bag and paced around like a lone wolf. "How the hell am I going to do this?" I spoke the words aloud. My head was spinning with road maps, drawings, photographs. After a few minutes the spinning stopped and one thing became quite clear to me. I could no longer

follow Vincent's movements step-by-step or even year-by-year. I would have to decide to see some places, and skip the others. The idea infuriated me, but I no longer had any choice. That deadline seemed closer every time I looked at it.

So what came next? From the Hague Vincent went to the isolated province of Drenthe, in the northeast of Holland, where he spent a few lonely months. Then he returned again to his parents who had moved to Nuenen in the south of the country.

Old Piet van Hoorn, the centenarian who knew Vincent, had already talked to me about the painter's stay at Nuenen. Of course, what he had told me about Vincent had much more significance now that I had been following his life so closely.

A series of unfortunate events—the attempted suicide of Margot Begemann, the next-door neighbor who fell in love with Vincent, his father's death, and rumors (denied by Vincent) that he was the father of the baby of Gordina de Groot who was a model for *The Potato Eaters*—made Vincent pack his bag and leave Holland for good.

In the spring of 1885, the painter traveled to nearby Antwerp in Belgium and became a pupil at the art academy there for a while. His professor thought his drawing inadequate, however, and put him back to a preparatory class. He studied Rubens and learned to brighten his palette.

While all this was interesting from the point of view of Vincent's artistic development, I didn't think there would be much of personal interest during his short stay in Antwerp. The Paris period I had learned about from Baroness Bonger. Perhaps I should head directly for Arles. Digging out a letter I'd received from Dr. Tralbaut, I saw that he was going to be in Provence only briefly. If I delayed my trip there I might miss him. That made the decision for me.

I packed up my things and drove off—after one of the shortest night's sleep I'd ever had. As I sped along the dark, narrow roads that led out of the Borinage, making south for the French border and the autopaysage to Arles, I realized that something about this assignment had caught me and held me fast. It was more than an assignment now. I didn't know exactly *what* it was, but I did know that I would not be satisfied with the limitations of my deadline. I would return one day to the places and mysteries that time was now forcing me to skip.

Chapter four
Mistral

The countryside was dark and silent as I made my way down small lanes toward the main road that would take me south, over the French border. Already I had doubts about the wisdom of driving alone and at night—some 500 miles lay between me and Provence, and I'd had little sleep the night before—but I pushed on anyway. Through the Marne and Haut Marne, past Reims and into the flatness of Burgundy. Past Dijon I joined the autoroute, which made the driving faster but more monotonous. When I felt my eyelids threatening to clamp shut, I pulled over and slept for a few minutes.

And always, while awake, my thoughts jumped back and forth among the sequence of Vincent's life, the events of the last few days, my deadline, my plans for the rest of the trip. At moments it all turned into a jumble. I was following Vincent through books, visiting places where he had lived, talking to people about him. What had I done, what had I read, whom had I talked to? Who was it who was going to Provence, me or Vincent? He had fled there after his tempestuous stay in Paris, which the Baroness had told me about. In a letter to Theo he wrote of his need to "take myself off somewhere down south, to get away from the

sight of so many painters that disgust me as men." As I recalled these words by the roadside, I laughed aloud. What would the painters have said about Vincent? But at least he had his convictions to propel him south. All I had was a deadline, a scribbled-up notebook, and a tiny drawing. I looked at the drawing again and again, sometimes holding it on my lap as I drove. It seemed to bring me closer both to Vincent and to the reality of my assignment. Was it really a van Gogh? The question didn't seem to matter so much any more.

Just past Avignon, dawn began to break over the Alpilles mountains. Slowly the darkness gave way to a soft purple, bathing in radiance the lush cornfields of Provence. It was another world from the bleakness of the Borinage.

At Tarascon I left the highway at last. It was a relief to take a country road again. Stopping the car, I walked up a hill to stretch my legs and breathe the crisp morning air. (Needless to say, I had the drawing and photographs with me. They were trusty traveling companions by now.)

Physical exertion made me realize that I had barely moved a muscle for hours. My eyes ached from exhaustion, my legs were stiff and tight, my throat was dry and my stomach empty. At least I was able to quench my thirst with bunches of succulent black grapes and to wash my face in the morning dew.

With my face still wet I sat down to watch the sunrise. The same dew in which I'd washed my face hung like teardrops from the somber green branches of the cypress trees. They twisted as if in agony out of the fields, clutching and leaping at the empty sky. Symbols of death, Vincent had called them. In this dazzling display of copper, bronze and gold I could see why. Their beauty was almost unbearable. Suddenly I was aware of tears starting to grow behind my eyes.

This was more than I could cope with. I arose abruptly, as if to shake myself soundly. "Come on, Kenneth. You're

just tired." I spoke the words aloud. The sun was now fully launched, and the day was beginning. With parcel in hand, and the last remnants of dew drying in my beard, I stumbled down the hill toward my car. I wanted to find Tralbaut.

Tralbaut's address was in Mausanne, a village not far from Arles. The drive there was an uninterrupted spectacle. Every turn held another field, another stand of cypress trees to look at. My vision was affected as much by Vincent's intense interpretations of these views as by the scenes themselves. I found that I couldn't tell the difference between what he had seen and what I was seeing myself.

The drive took about an hour and a half, and led me to a tiny village consisting of small houses well spread out over a large, hilly area. A villager pointed me in the direction of Dr. Tralbaut's house, which was seated on the side of one of the hills. Getting there meant taking my car up roads barely wide enough to accommodate it.

By mid-morning I reached the house, but there was no one at home. I walked up the hill (with envelope, of course) to a point from which I could see the Crau valley, where Vincent painted for days on end in the burning heat. The sun had turned lemon-yellow as it eased up into the sky and filled the air with a blinding light. The glowing cornfields below were being whipped by the prevailing wind the Arlesians call the Mistral. I remembered Vincent's descriptions of painting in that wind—of how difficult it was to keep the Mistral from blowing away his easel and canvas. In the distance, near a cluster of olive trees, I saw a stooped figure with a straw hat climbing a hill path that led to Tralbaut's home. I walked back down the hill toward him and saw it was the author himself. I recognized him from a photograph I had seen at the van Gogh Museum.

As we came nearer each other, Tralbaut called out: "You must be Kenneth Wilkie. I had a premonition you

would arrive today." He greeted me warmly and we walked together to his house.

Tralbaut's home was spacious and simply decorated. Surprisingly (for an art historian), the walls hadn't a single picture on them. The main decorative motif, if you can call it that, was the crammed bookshelf. I had never seen so many books in a house before.

Over a bottle of Provençal wine ("one of my favorites," said Tralbaut), we talked of my travels and discoveries. He was enthralled by the drawing.

"Scholars spend lifetimes hoping they will discover an unknown drawing by a major artist. Of course, I'm not saying that what you have *is* by van Gogh. I would have to make a detailed study to be sure. But it looks to me that it may well be. That is judging purely by the style—not even taking into account the circumstances in which you found it. The trees are the point of departure. I would like to see a microphoto of the trees. Then I would be sure.

"Even if the drawing proves not to be a van Gogh, you have made an important discovery in the photographs of Eugénie. Your postman friend, Mr. Chalcroft, is to be congratulated for his researches. Strange, isn't it, the ways people get drawn into learning about van Gogh. . . ."

Tralbaut told me that he felt he himself was predestined to be a van Gogh scholar. He was born in 1902 on a boat called the *Theo* as it was passing Vincent's resting place in Auvers-sur-Oise. He talked of the years he had spent researching Vincent's life and work—of the trials and frustrations, the joy and satisfaction.

Now Tralbaut was living in semi-retirement in the land that Vincent had loved so much. Even at the age of seventy, however, he couldn't leave Vincent completely: he was in the process of finishing a book on the influence of Japanese prints and paintings on Vincent's art. And much of his time was taken up with the van Gogh scholars and enthusiasts who came down to Provence to visit him. A team

led by the Swedish director Mai Zetterling, who were making a film about Vincent near Arles, had just been to see him.

"And last week," said Tralbaut, "I had a visit from an Englishman called Alfred Schermuly. Schermuly had been in a mental hospital as a result of war injuries. But in the hospital he read my book, became absorbed in Vincent's life, and began to paint. He is now a full-time painter and lives with his wife and family again. He had made the pilgrimage to Provence to absorb the atmosphere here. Just as you have."

The afternoon was wearing on, as was our bottle of wine. I sensed that Tralbaut was looking forward to an afternoon nap, and decided it was time to take my leave. First, of course, I wanted to get from him any possible leads in Arles. I explained that I was trying to find people with a living link to Vincent, and asked whether there would be any in Arles.

Tralbaut took the question seriously, but assured me that there weren't any living links to be found around there. "As you know, van Gogh had few contacts here, since the townspeople mostly thought he was out of his mind. The daughter of the postman Roulin, Vincent's friend, died in Marseilles some years ago. No, I'm sure there's no one here.

"But if you go to the asylum at St. Remy, I can give you the name of a café in the village that used to be frequented by an old man called Poulet, whose grandfather was Vincent's warder in the asylum. I'm not sure if he's still alive, but if you find him he may have something to tell you."

Tralbaut also mentioned that if and when I visited Auvers-sur-Oise, where Vincent died, I should try and trace the descendants of a certain Madame Liberge. I wrote down the name.

Tralbaut walked me out into the blazing afternoon sun.

"Do keep me informed of what you are doing. I know you will find new things, because you search with the dedication that one needs for a subject like van Gogh. His greatness inspires greatness in oneself. Good luck." We shook hands and I started walking again down the hill. My eyes seem to be filling with pools of sunlight.

"Where to now?" I thought as I walked down the hill. Arles being the most written-about period of Vincent's life— when his mental illness broke at the height of his creativity —I was hardly treading virgin territory. I laughed at a mental image of dozens of Vincent researchers covering every square inch of Provence with notebooks and magnifying glasses. "And they've probably all walked down this same hillside." Oh well. All I could do was keep my eyes and ears open, and not get discouraged. And, as always, remember the deadline, which was a mere seven days away. I swallowed my panic as it rose in my throat.

I decided to pay a visit to the team of people making the film that Tralbaut had told me about. After asking around a bit, I traced them to an old farmhouse in the valley of the Crau, and introduced myself to Mai Zetterling, the leader of the group. She introduced me in turn to cameraman John Bulmer and actor Michael Gough. They had rented the farmhouse for five months with the purpose of exploring the genius and suffering of van Gogh during his stay in Arles. Michael Gough was living the part of Vincent. Like Vincent, he was starving himself of luxury and even necessities.

"At one point I wasn't speaking to anyone and I'd live on nothing but coffee and brandy for three days then go out in the boiling heat to work to see what it does. It had an extraordinary effect. Enough to make anyone go mad. . . ."

Gough admitted that he had grown to love Vincent. "In a way the film has turned out to be not really about van Gogh at all, so much as the action of creation," said

Gough. "That, and the attitude of society to the artist and the effect of the artist on society. I found the more I looked into the area of van Gogh's madness, it seemed to me that so often the way we treat the van Goghs of this world—the people who are not of the establishment and are unorthodox in their attitudes—is a bit like baiting a bull. You bait him until he charges, then you say: Kill him!"

As Gough talked I detected something akin to the look of mild fanaticism I first saw on the American I had knocked over on my bicycle earlier in the year, and in the postman Paul Chalcroft. I began to wonder if I was looking that way myself.

I left the group as they were preparing to get back to shooting. They were hardly a living link with Vincent, but in Michael Gough I had found a different kind of link: a testament to the profound effect that Vincent has on people today. How many artists, however great, have the same kind of effect?

After leaving the film group, I went into Arles, which is built around a Roman amphitheater on the River Rhône and has a labyrinth of narrow winding cobblestone streets. I headed first for the Place Lamartine. Vincent had rented a yellow-painted house there for a while with Paul Gauguin. The Yellow House, as he called it, has gone, but the house behind it, called the Hotel Terminus van Gogh, is still standing. The building can be seen in Vincent's painting of The Yellow House.

I took a room at the hotel, as I hadn't slept in a bed for several nights. Climbing the staircase, I noticed, framed on the wall, a little photograph of a destroyed building with a woman running from it. I recognized that it was The Yellow House. Looking closely, I saw that the hotel in which I was now standing was in the picture, too.

When I went back downstairs, I asked about the picture. The hotel-keeper told me that it had been taken by a war correspondent after The Yellow House was bombed by the

Nazis in 1944. In the early '50s the reporter had come back as a guest and given her the photograph. The Yellow House now exists only in pictures—it was never rebuilt.

That evening, after a light dinner, I strolled around the square. Across from the hotel in the Place Lamartine is a place overlooking the Rhône where, during the day, the old Arlesians play bowls in the shade of the chestnut trees. This was the spot where Vincent painted his first *Starry Night*, with candles fixed to his hat to give a little light. I stopped at a café nearby and had a few glasses of pernod, the drink most similar to absinthe, which Vincent had drunk here. Absinthe is no longer legal, having been proven to affect the sight and contribute to insanity. The authorities banned it in the 1930s when they became worried by a proliferation of blind madmen. Considering the amounts Vincent drank, it must have had some effect on him. By my fourth glass of the weaker drink, I was feeling a bit peculiar myself.

Easing my way to an unsteady upright position, I made my way across the square. On the other side is the site of the Café Alcazar, the scene of the painting *Night Café*, in which Vincent intended to show "a place where people could go mad or commit a crime." Nearby was the brothel where he and Paul Gauguin used to go for what Gauguin called "nocturnal promenades for reasons of hygiene." But there's not much to look at anymore: both the Alcazar and the Maison du Tolerance have made way for a supermarket. I tried to imagine what they might have looked like by remembering Vincent's pictures. I don't think he would have known what to make of a supermarket.

Feeling the need to rest my feet again, I walked over and sat on a wall by the banks of the Rhône. From there I looked across the Place Lamartine toward the spot where The Yellow House once stood. That ill-fated house, in which Vincent had dreams of establishing a kind of commune where "a community of painters" could pool their

resources and live and work together under the same roof.

All his life he seemed to be seeking that type of haven, where love or the spirit of good fellowship formed a protection against the indifference and hostility of the world. In Arles he had found a seemingly ideal situation for his artistic family—yellow, the color of the house, was for Vincent the color of friendship—but his dream was to end in disaster. The only artist he managed to coax to Arles was Gauguin, and their relationship ended in anything but happiness.

Sitting on the wall, I thought about their brief time together. Gauguin, originally a well-paid stockbroker, had packed his wife and family off to Denmark and chose to devote his life to painting. A Frenchman with Creole blood, he was worldly, lucid, cool and quick-witted. Vincent was the opposite—intense, explosive and had difficulty in expressing his thoughts verbally. He also worshiped Gauguin. The two painted together in the blinding heat during the day and became intoxicated by absinthe and tobacco at night. It wasn't long before their nerves and tempers began to fray. Gauguin didn't share Vincent's belief in universal goodness, and thought his paintings naive. He often teased Vincent, and the two were frequently at loggerheads.

The tensions culminated in a series of dramatic eruptions in the fall of 1888.

In his memoirs, written fifteen years after Vincent's death, Gauguin told how one evening when the two were drinking at a pavement café, Vincent suddenly threw a glass of absinthe at his head.

The sequel to this incident, by Gauguin's account, took place on Christmas Eve in the Place Lamartine. As Gauguin told it: "In the evening I had a snack for supper and felt the need to go out alone to take the air that was laden with the scent of oleanders in bloom. I had crossed almost the whole of the square when I heard behind me a light step.

It was rapid and abrupt and I knew it well. I turned round, just as Vincent was coming at me with a razor in his hand. I must have looked at him then with a very commanding eye, for he stopped, lowered his head, and turned around and ran back towards The Yellow House."

The third act of the melodrama was even more bizarre. This time the police were called in and the local press reported the event, telling how (on the same night as the attack on Gauguin) Vincent had appeared at a brothel near The Yellow House and given a parcel containing the lower half of his ear to a woman called Rachel, saying: "Guard this object carefully." The girl fainted when she saw the piece of ear and, according to the local newspaper report, the police found Vincent back in his bed the next morning, unconscious. He was taken to the hospital in Arles, accompanied by his friend Roulin.

Reviewing these events in my head, I got up and walked around the square again, tracing as best I could Vincent's footsteps when he crept up behind Gauguin with the razor in his hand. With my head cocked and eyes toward the ground, I held the imaginary blade in my hand. What was going through Vincent's mind as he walked those silent steps? I had nearly reached the other side of the square, where Gauguin said he turned around and found Vincent following him, when I heard a shuffling noise behind me. I swiveled around abruptly—to find an old woman in a shawl staring at me. I don't know which of us was more surprised. I murmured a few words in French and walked back toward the hotel. Had the sun been out she would have seen a brightly colored blush creep over my face. I slept very soundly that night.

Next morning I visited the hospital in Arles and photographed the quadrangle at the same angle from which Vincent had painted it after his recovery. But the interior had changed beyond recognition. No one remembered Dr. Felix Rey who treated Vincent, and the Roulin family

had since died out, as Tralbaut had told me, in Marseilles.

After asking a few other passers-by whether they might know of a relative, a friend, a postman, whose ancestors knew van Gogh or had some connection with him, I decided that Tralbaut was certainly right. There were no living links to be found in Arles. What really surprised me was that they looked at me as if *I* were some kind of strange fellow. Asking about a painter who sliced his ear up and went into a mental hospital? Dead for eighty years? Perhaps they had all heard about me from the old woman I met in the square the night before. I felt as isolated as Vincent must have.

I sat alone in a café and had lunch—an omelette and some red wine. What had I done in Arles? I had found no drawings, no descendants, no major photographs. I shuddered to think of Vernon Leonard, who was probably looking at his calendar back in Amsterdam, waiting to see whether I would meet my deadline. What would he say about the two days I had spent here? I wasn't even sure of what I would say myself. Was I wasting time? Was I going crazy? Something was overpowering the professional journalist in me. I was now looking for something more than "the story."

I spent a long afternoon walking through the fields that surround the town. I absorbed the power of the sun, drank in the mad colors of the sky, the green fields, the riots of flowers. I found myself peering through the camera into the hearts of sunflowers, going down on my knees to get close to the corn, the vines, the twisting olive trees. The somber cypress trees seemed always present. I thought of how Vincent must have identified with them. They appeared as incongruous to me in the Provençal landscape as Vincent must have felt in the community of Arles.

As evening fell my thoughts returned again to the question of where to go next. For once there weren't too many choices—Vincent's next stop was only twenty miles away.

After his ear had healed, he started to paint feverishly again. His sense of the universal rhythm of nature returned and he was painting up to thirty-seven canvases without a pause. After his breakdown, however, he had a lot of trouble from the Arlesians. They continually pestered and taunted him, and finally drummed up a petition asking the mayor to "lock up this madman." The police closed The Yellow House. (In its brochure for Arles, the city's tourist office apologizes for the way the community treated van Gogh. "We hope to make up for it by being more hospitable to you.")

Vincent now found himself friendless. Gauguin had gone. Roulin had moved to Marseilles. In March 1889, realizing he had experienced three crises in four months, Vincent committed himself into the Saint-Paul-de-Mausole asylum in the hill village of Saint-Remy de Provence.

It was obvious that I should go there too. Tralbaut had told me of someone who might have something to tell me, and I wanted to see the place where Vincent had spent over a year struggling with his madness. I decided to sleep out in the hills near Arles, and drive on the next morning to St. Remy. I stopped in a café for a few pernods and a sandwich, and, as the sky darkened to night, headed for the countryside.

The night sky was brilliant, shimmering and sparkling with stars. Lying in my sleeping bag, with the envelope under my head, I thought about the *Starry Night* that Vincent painted in Saint Remy, with its sleeping houses, the black flames of cypresses surging into a deep blue sky with whirlpools of yellow stars and the radiations of an orange moon. The painting seems an attempt to liberate himself from overpowering emotions. In the depths of his loneliness, he animated the heavens with dynamic and furious motion.

Creeping back to the car, I got out my copy of Tralbaut's book and a flashlight, and crawled back into my sleeping

bag. There was a quotation from a letter that I wanted to re-read. Writing to Theo, Vincent said:

> Looking at the stars always makes me dream, as simply as I dream over the black dots representing towns and villages on a map. Why, I ask myself, shouldn't the shining dots of the sky be as accessible as the black dots on a map of France? Just as we take the train to Tarascon or Rouen, we take death to reach a star. . . .

I lay back in my sleeping bag and thought of Vincent's sense of isolation, of his own fear of his illness. He wrote to a critic that the emotions aroused by looking at the cypress trees were strong enough to incapacitate him for weeks. The intensity of his response to nature made him, he said, a coward.

Lying alone under the sky, I wondered whether I could ever sympathize completely with Vincent's illness. The rational side of me said that I didn't want to: Who wanted to experience his suffering? But another side of me told me that Vincent's nephew, the Engineer, was right: There was something of Vincent in all of us. Lying there under the night sky he had fought to capture in his canvases, I felt that solitude he spoke of so often. It chilled me. I had to struggle against the influence of something stronger than myself, something that would take my will away as he said his was taken. I convinced myself that I was physically exhausted—I still hadn't slept much since I'd been traveling—and needed a hot meal. In the morning I would be all right. Finally, my head full of reassurances, sleep came. It was just after midnight.

About three hours later, I woke up again. The full moon was staring me in the face. The stars were dancing around in the deep blue of the sky. In the distance I heard howling. Just a dog, I thought. There can only be one lone wolf out tonight. Nothing to worry about. But I didn't sleep. I

felt that I was being watched by the inhabitants of the night sky, and I couldn't get them out of my mind. Finally I gave up yet again on a night's sleep. I reread Tralbaut, I walked around, I scribbled in my notebook. When sunlight came I welcomed it as an old friend. I washed my face in the dew, as the early morning mist slowly lost its grip on the vines and evaporated into a purple haze.

After sitting a few moments to watch the play of light on the cornfields, I packed up and got into my car.

Next stop, the asylum.

Chapter five
In the Asylum

The asylum began life as an Augustinian monastery, and was converted to its present use in the 1880s. It seemed a friendly enough place as I walked toward it with camera, notebook and envelope tucked under my arm. Friendly by the standards of a nineteenth-century prison, anyway— I still remembered Vincent's descriptions of his fellow inmates shrieking and crying. I hoped not to hear too much of that.

The whole compound is surrounded by a high wall, and can be entered only through an iron gate. I was surprised to find the gate unlocked, and just walked in. Strolling down the shady drive that led to a side entrance, I kept looking behind me—something I never used to do—till I bumped into a massive metal door. I pulled the bell. After a minute or so, the metal latch of the rusty old peephole opened. For a few seconds I had the uncomfortable feeling that "they can see you but you can't see them." I smiled, trying to look as innocent and sane as possible under the circumstances.

The door creaked open, and a little nun stood in the doorway. She was frail but had eyes like a stoat. She introduced herself as Sister Marie-Florentine.

"Good morning, my son. Have you come to join us?" Her beady eyes beckoned a positive reply.

"Well, not quite yet," I replied. There was something ominous in the way she asked the question. "I am under a different kind of order. I am writing about Vincent van Gogh. I believe he lived here in 1889, sister?"

"Yes, he did, my son." I didn't like the way she called me "son."

"I was wondering if I could take a few photographs from the window of his room—if it still exists?"

"Of course, my son. I will take you to his room. Come this way." She spoke as if Vincent was still living there and was waiting for me. "This part of the hospital has not been in use for many years."

On our way down the dark stone-walled corridor Sister Marie-Florentine asked me twice if I knew that Nostradamus was born in Saint-Remy. Twice I told her that I didn't know but would bear the fact in mind for future reference. Perhaps she was a relative.

Near the end of the corridor we stopped at a door. Sister Marie-Florentine brandished an arsenal of keys which looked like it weighed slightly less than I do, and suddenly the door swung open.

I don't know what the inmates' cells looked like in 1889, when Vincent lived at the asylum, but I can't believe they were quite as comfortable as the cells that visitors are shown today. That's to be expected, I thought. You don't want people thinking you used to run a chamber of horrors. But when I stepped to the window to take a picture, I was even more surprised. The view from that window is definitely not the one that Vincent painted. After hemming and hawing for a few moments, I pointed this out to Sister Marie-Florentine. Her smile turned immediately sour.

"Non! Non, monsieur!" I had suddenly turned from her son to "monsieur." "Vincent van Gogh slept here. He had

his fits here!" She was obviously under orders to tell this to visitors. I showed her a reproduction of one of Vincent's views from his window, reproduced in Tralbaut's book. But she was adamant.

"You are mistaken, monsieur. Monsieur van Gogh lived in this room."

Well, not much point in arguing, I thought. I dutifully clicked off a few frames and changed the subject.

At Theo's request, Vincent was permitted to paint in the grounds of the asylum. In one of the works he did here—a *Pieta* copied from a work by Eugene Delacroix—Vincent gave Christ his own features and Mary the features of Sister Epiphany, the mother superior of the cloister. I had seen mention of Sister Epiphany in Vincent's letters and wondered whether she was still remembered.

Apparently she was. When I showed a photograph of her to the nun, she clasped her hands and fell trembling to her knees.

When she was through mumbling, I asked her about Sister Epiphany.

"She was a living saint," said Sister Marie-Florentine. "So good. So kind. Everyone loved her and treasures her memory still today."

"Vincent seemed to have a very high regard for her too," I said.

"Yes, and Sister Epiphany had a special place in her heart for the painter van Gogh. On more than one occasion she stopped him from eating his paints. She was very sad when Monsieur van Gogh left here."

"I would have expected her to be glad he was well enough to leave," said I.

"Ah yes," replied the sister, with a glint in her beady eye. "But he was a very special case. You must agree. People respected him here and left him alone to work. Here he found peace. And we of the Saint Paul de Mausole asylum are proud we had him. You see these flower pots?"

she said, complacently pointing to a bath full of earth in the corridor. "Well, that was the bath where Vincent spent hours as part of his hydropathic treatment."

"With water and not earth in it?" I cracked a sickly smile that felt quite out of place in the cell.

"Water, naturally," replied the nun. Her eyes narrowed suspiciously. No more jokes in here, I thought.

"What was his diagnosis?"

"Either epilepsy or schizophrenia. He was originally diagnosed as an epileptic, but today people are not sure."

From my reading I knew this to be the case. I made a note for future reference to delve further into Vincent's illness.

While we were talking, I continued to think about which room Vincent had really stayed in. I glanced occasionally out of the window, gauging distances and looking at the trees in the courtyard. Finally I decided that it was upstairs, one flight up. I raised the subject again with Sister Marie-Florentine.

"You know, I think that the room van Gogh stayed in might be upstairs. If I could have a look . . ."

"Monsieur, you think incorrectly," she cut in. "If you do not believe that this is van Gogh's room then that is your affair. Everyone is entitled to his own belief. But that means there is no longer any reason for you to be here." She rattled her chain of keys.

"Just a quick look?" I said. I raised my eyebrows like a little boy trying to persuade his mother to take him into a toy shop.

"Non! Non! Non!"

"You know I've come all the way from . . ."

"Non! Let me show you out." Sister Marie-Florentine took me by the arm and walked me back down the corridor. We stopped in front of the door.

"Goodbye, sister."

"Goodbye, my son." Her smile was as sweet as a razor.

To hell with this, I thought as I trudged down the drive. Looking back, I could see the sun reflecting off her glasses behind the peephole. What a life. I wondered how long I could keep sane in there.

In the olive grove at the back of the asylum wall, I photographed the trees at close range. Vincent had painted and drawn them often, seeming to find in their twisted forms a mirror of his own torment.

The mid-morning sun was now climbing to its peak in the blue expanse of sky, and the air was hot. I trudged up a hill overlooking the back garden of the asylum and dropped wearily to the ground. The sun was making me sweat, but Sister Marie-Florentine's obstinacy had made me fume. How does she know? What's she so worried about? I stared angrily into space.

Suddenly I realized that the garden below me was the one that Vincent had painted from his window. Click. A crazy idea appeared in my brain. If Sister Marie-Florentine wouldn't show me the upstairs of the asylum, I was going to go there myself. I would get my picture yet. Let her and her chain of keys try to stop me.

Studying the angle of the painting that Vincent made from his window, I deduced that his room was probably a couple of floors up from Sister Marie-Florentine's shrine of reflection. I even made a guess as to which room was likely to be his. Now all I had to do was find a way of getting in there.

Surveying the terrain, I figured that if I climbed the telegraph pole at the foot of the asylum wall, I could crawl along the top of the wall and enter Vincent's wing through a broken, barless window I noticed. And providing it wasn't Sister Marie-Florentine's private toilet, I would be all right.

So up the pole I went—drawing, camera, book and all.

When I was about six feet off the ground, a Doberman Pinscher and another ferocious mongrel bounded, fangs

bared, at the spot where I had been standing seconds before. My eyes bulged in disbelief. Surely they could see that I was trying to get in, not out. Surely they didn't think that I was an inmate. Surely . . . I didn't wait around to find out what they thought. Pulling myself up as fast as I could, I finally made it to the top of the garden wall. They were still down there, yapping away. Now I've done it, I thought.

Crawling along the garden wall like an intrepid old cat, I suddenly felt a bit ridiculous. Perhaps the Arlesian sun really had begun to affect my head. I mean, who in his right mind would risk encountering Sister Marie-Florentine again after her breakfast of gruel and newts? And who would believe me if I told them what I was trying to do— that armed with a drawing I suspected was a van Gogh, and looking like he must have on one of his bad days, I was trying to break into his asylum cell? Could I blame them if they tried to keep me in?

Anyway, there was no turning back now. Apart from any doubts I had, it was physically impossible for me to turn around on top of the wall. After ten minutes of crawling, I reached the broken window and looked inside. The room was empty. I stuck my hand through the window, raised the rusty old latch, and crawled in.

The walls of the room were damp and peeling. The whole place smelled like moldy mustard. As there were no bars, I supposed it had probably been a warder's rest room. Easing the door open slowly and gently, I tiptoed down the damp corridor past a statue of the Virgin Mary. She seemed to be looking down accusingly at me. As a rat scurried away into a cell on my right, I wished I had never gone that far.

The old wing was falling apart (like me), but it was un-mistakably the same place that Vincent had painted and described in his letters. The faint sound of my footsteps echoed the steps of the unhappy souls who had walked here

before. Vincent wrote in one of his letters that the more time one spent with them, the less one thought of them as mad.

At the end of the corridor I found a narrow stairway and climbed it to the floor I thought was Vincent's. It was much the same in appearance as the one below.

I nosed into the empty cells, one by one. Each was exactly like the one next to it, except for the view. Which was, of course, all I was interested in. I'd show Sister Marie-Florentine yet.

Finally I found the view Vincent had painted, with the garden (now overgrown) and the Alpilles sloping away in the background. The hunter and his prey, the fisherman and his catch. This was what I'd been looking for. Yet . . . somehow I didn't feel quite the thrill I ought to have felt. Before I had been like a child in front of a toy store. Now I was actually inside the store, but had discovered the toys weren't nearly so much fun to play with as they were to look at. Oh well. At least I could record the great discovery on film. I made several exposures to be sure of getting the right one, and that was it.

I felt the dampness creep into my bones. This place was enough to turn anyone into a depressive, I thought. Perhaps it was cozier with a few other inmates around. And in the 1880s, Sister Marie-Florentine would certainly not have been there. At least not in her present form.

There was only one thing I wanted to do now: get out quickly. I crept along the corridor and down the stairs, hoping to get out by the door this time. Shit! It was padlocked. Only one thing left to do and that was climb back along that confounded wall. I tiptoed upstairs again and, as I was making for the room with the broken window and my freedom, I heard an ominous jangling of keys.

I didn't have to think twice about who was on the end of that key ring. I tried one cell door. Locked. Another. Locked. Two more. Locked. Locked. Hell! The jangling

was coming closer and any moment I expected Dracula's answer to Audrey Hepburn to appear around the corner. There was only one refuge in sight: a huge stone statue of the Virgin Mary which stood between me and the direction from which the jangling was coming. I crouched behind the statue, clutching my equipment, and waited.

Along she came, padding softly down the hall. Suddenly her footsteps stopped. She was right in front of the statue. I thought the game was up. What should I do? Pray? Then I heard her mumbling a prayer herself. Of course! she couldn't pass without paying her respects. I held on tight. The prayer went on . . . and on. It felt like half an hour I was bent double at the feet of Holy Mary. But it couldn't go on for ever. I prayed she would stop praying. And it worked: Sister Marie-Florentine rose and went on her merry way. I suppressed my laughter. As soon as she was out of sight, I darted back to the room with the open window. I reached the window and began to crawl back along the wall. All was going well until I reached the telegraph pole. Oh no! The dogs were still there, gnashing their teeth in anticipation.

What now? All I could do was sit there. It was too far to jump and only a lunatic would feed himself to these two man-eaters. I waited. They waited. I like dogs so I found it natural to talk to them in a nice way, but they weren't amused. Ten minutes passed. Fifteen minutes. Half an hour. The wall was narrow and uncomfortable. I sat in every possible position and finally ended up lying on my stomach. Was this a Sister Marie-Florentine torture? Had she noticed me all along and just let me think I got away? I contemplated how Vincent would have painted her. In my imagination I worked her into a Hieronymus Bosch torture scene.

About forty minutes passed before someone came by. It was a man with a hunched back. He looked up at me and waved a crooked walking stick.

"What are you doing up there?"

I was afraid he would ask that. I began to explain, but when it became complicated, he interrupted.

"I'm the caretaker of this asylum," he said. "No one is allowed to leave the hospital without the authorization of the mother superior or the doctor-in-charge. Climb down and come with me!"

"I'd have done that long ago if it weren't for these dogs."

"Yes, I bet you would have. And it's just for the likes of you that we keep them here!" But he obliged me by whistling to the dogs, who abandoned their duties and wagged over to the caretaker's side. I clutched the drawing and camera to my sides and slithered down the pole. It felt good to touch earth again without fear of losing a leg.

Unfortunately I made some sort of sudden movement, for the dogs began their barking and took a few steps in my direction. I was getting ready to climb the pole again until the caretaker called them off.

"Boris! Vincent!"

I couldn't believe my ears. "Did I hear you say *Vincent*?" One of the dogs looked up at me with his head cocked.

"Yes, Vincent," replied the caretaker indignantly. "He's the shaggy one with the red hair. Come on now, don't keep me waiting."

I didn't know whether to laugh or cry. Perhaps laughing would be less suspicious.

We walked toward a modern building adjacent to the old asylum. On the way I tried to explain myself, but the man just nodded and agreed with everything I said. He clearly thought I was a lunatic and felt he had to humor me. In the end I got tired of repeating myself and shut up. We entered the hospital and stood at the registration desk.

"I found this man escaping over the wall," said the caretaker proudly.

"That's a lie," I retorted. "I'm a visitor. I didn't escape. I broke in . . . I mean . . . I just wanted to photograph

Vincent van Gogh's cell. You see I'm. . . ." Sometimes words fail you when you need them most. A doctor was called in. I introduced myself.

"Now Monsieur Wilkie," he said in a sickeningly sympathetic voice, "you tell me all about it. You can say anything you like to me. Don't worry. . . ."

I asked him to *please* check the hospital register, which would prove I was not an inmate. This was done and at least that was settled. But the doctor seemed to feel that he had some sort of grip on me.

"Now if you feel you need to come here," he said, "we would prefer if you would approach us through the official channels. You will find that Monsieur van Gogh did so through his brother."

What a lunatic irrelevant remark, I thought. I gently informed the doctor that I was not ready to come into his cozy little establishment and didn't expect to be ready for a while; that I was a serious, respectable journalist and resented his implication that I was off my rocker; and that he should watch what his dogs got their teeth into, because what they were offering to administer was anything but tender loving care. My voice rose slightly as I neared the end of my little speech. Time to leave, Kenneth. Get out of this place fast.

I said goodbye and headed into Saint Remy. My hand shook slightly and I was still angry. What was going on? Maybe there was something about the atmosphere of Provence that affected the brain. A drink was certainly in order.

I went to the café where Tralbaut had suggested I might find old Poulet, whose grandfather was Vincent's warder in the asylum. While ordering a pernod, I asked the proprietor if a Monsieur Poulet frequented his place.

"Old Poulet? Oui, monsieur, he's due in any minute."

I sat down at a table near the counter and a few minutes later the café owner nodded to me as an old man with

white hair and cheeks like fresh apples came shuffling up to the bar. He ordered his usual, which was a St. Raphael. I went up and explained what I was doing and asked him if he would be kind enough to join me. He did so gladly. I got straight to the point.

"Did your grandfather have any connection with van Gogh?"

"Oh yes," said the old man. "My grandfather was a warder at the asylum, you see, and he used to take van Gogh out into the country around Saint Remy. They went on long walks and van Gogh would take his paints and easel with him."

I asked Poulet what Vincent told his grandfather about himself.

"Ah, monsieur," he replied, "alas nothing. My grandfather said that van Gogh would not utter a word to him—either in or out of the asylum. But he would paint quietly. My grandfather said that Monsieur van Gogh lived in his own world but seemed to know what he was doing.

"Very occasionally he would become violent. On one occasion he kicked my grandfather in the ass for no reason as they were going up the asylum stairs. He didn't tell me much else, my grandfather, apart from one story about van Gogh's paintings that you may be interested in."

"I am. Go on."

"Well, Monsieur van Gogh left behind him at the asylum a case of canvases and my grandfather saw what happened to them," said Poulet. "The son of Monsieur van Gogh's doctor, Dr. Peyron, found the case and showed the canvases to his friend, a boy called Henri Vanel. The boys decided to use them as targets for their bows and arrows. They stood the paintings up on the steps of the asylum and shot holes in them till they were in tatters. Only much later, when the strange painter van Gogh became so famous, did they realize what they had destroyed. Who knows? Oh, people do the *craziest* things in this part of the world. . . ."

Chapter six
Yellow Flowers

After a few drinks with old Poulet, I left the café and walked around. I was calming down a bit from my episode with Sister Marie-Florentine, the good doctor, and the asylum guard dogs. If I really was going slightly batty, it wasn't happening all at once. I still had the ability to think about where I was and what I was doing.

And the picture was not an entirely rosy one. It was now Thursday afternoon. I was nine hundred miles from Amsterdam. I had to be back there by 9 AM Monday, and between now and then I wanted to visit Auvers-sur-Oise, where Vincent had spent his last three months. Tralbaut had told me of someone to look up there, and it did seem a logical place to end my trip. Worse still, I also wanted to visit Vincent and Theo's apartment in Paris. Thinking about the lay-out of the article, I knew a photo of the apartment would go well with the Baroness's description of Vincent's life there. This was a good opportunity, and I didn't want to pass it up.

But how was I going to do it? The days of sleep I'd been missing were starting to catch up with me, I had hundreds of miles to drive and, to cap it all off, I was nearing the end of my money. I wanted more than anything to be in

Amsterdam—a hot bath, a good meal, and then fifteen or twenty hours of sleep. But that would have to wait. I got into my car and started driving. I tried not to think of anything except getting to Paris.

I arrived there very late and headed through the city toward Montmartre, the hilly district in the northern part of the city where Vincent and Theo had lived. I hoped to get a room near rue Lepic, their street.

No luck. The hotels were either full or no one answered the door. Well, at least the cafés are open, I thought. It's not exactly the best thing for my health, but I'll be able to enjoy myself.

While I was in the vicinity, I decided to walk down to 60 Boulevard de Clichy, to see what was left of the Café Tambourin, where Vincent used to carouse with men like Toulouse-Lautrec, Degas, Emile Bernard, Gauguin, and Emile Zola. A photo of that ought to be interesting, I figured.

Disappointment awaited me. On the site today is a sex club and a plastic and chrome café-restaurant called The Two Notes. No one in either establishment knew of a Café Tambourin. In The Two Notes I had a look in the back yard and could see that the building had been totally rebuilt. Nothing to look for here, it was obvious.

By this time it was nearly midnight and I knew I would do no more Vincent-hunting. Perhaps in a café I would find someone to share a drink and a good chat. I walked up the rue des Abbesses looking into one café after another. My precious envelope was by now soiled with wine and coffee stains, but the contents were protected by stiff cardboard and waterproof wrapping.

In the second café I stopped at, I met up with a French boy, a Breton who had lived in Amsterdam named Daniel Marais, and an Irishman about my own age, Gerald O'Keefe. O'Keefe tried to convince me that apart from being a flautist of some note he was the John Millington

Syng of the '70s. His first novel had been burning inside him for fifteen years and he was waiting for a W. B. Yeats to come along and discover him. After seeing how full he was of the Blarney—not to mention the wine—I told him jokingly that I thought he belonged in one of Samuel Beckett's garbage cans—a reference to Beckett's play *Endgame* where the characters appear in garbage cans. The remark was a compliment, but he didn't see it that way.

"I'll stick you in the bloody dustbin," he said, showing his formidable Irish charm. He lurched across the table and would have pounded me into it, but Daniel separated us. We made up and all three of us found common ground by investigating the contents of a number of wine bottles and making fun of the English. It was certainly better than sleeping in the car.

We ended up in the vicinity of Les Halles, the market, singing Gaelic folk songs, drinking bowls of onion soup, and doing the Highland Fling between bottles of wine. It was a wild night. That much I do remember.

I woke up the next morning with a pair of full breasts and a tousled mop of long dark hair dangling over my head.

"Wake up, Scotsman, I have to go to the office."

"Oh yes. I have to go back to the asylum. I was just let out for the day and it always ends up like this."

Where in Heaven's name am I, I wondered. And the drawing . . . the envelope . . . the envelope! I sat up with a start and looked around wildly. I heaved a sigh of relief to see it sitting below my underpants on the chair. Confusedly, I racked my brains to recall the sequence of events that brought me to wherever I was. She didn't look like a prostitute. But then, what did I look like? Oh well, I suppose that's what Gauguin meant by a "nocturnal promenade for reasons of hygiene." I checked that my ear was still attached and eased out of the bed. Sleepily, my companion asked for a little money. I couldn't give her much for I hardly had any left.

She left and I pulled my clothes on. On the stairs whom should I bump into but Gerald O'Keefe, the Irishman, looking like a leprechaun who had taken the wrong turn in a strange forest.

"You again!" He looked up through a raised eyebrow. "Is this a brothel we're in?"

"It could be an asylum," I said. "If you really want to know, why don't you ask the concierge?" True to form, Gerald did just that. In his mad mixture of Irish and French, he asked:

"Em . . . pardoner moi, madame, but am I bon in saying that cette maison is a bordello?"

No response. I could hardly suppress my laughter as the concierge looked straight in front of her and Gerald waved his hand in front of her eyes.

"I know, we're in Madame Tussauds," he said. "Well, whether it is or whether it's not, madame, I suggest you get your plumbing fixed. It kept me awake all last night." And out he stormed.

"You're not the quiet one I thought you were," said O'Keefe to me on the street. "You play a fine nose flute. We could make a fortune together in Dublin. You're a man after me own heart. How d'ye fancy a wee pick-me-up?"

"I've picked up enough for one night, Gerald," I replied. "You just wouldn't believe me if I told you all I had to do in the next twenty-four hours. But I won't tell you because you'd insist on coming along. Cheerio. Look me up in Amsterdam if you're ever passing through."

He disappeared with a wink through a café door and that was the last I saw of Gerald O'Keefe.

I went straight to the Banque Nationale des Pays Bas to arrange for a little money to be transferred from my account in Amsterdam to Paris. Coincidentally, this was the bank—indeed the same building—where Vincent received his allowances from Theo when Theo was out of the country. As it would take a couple of hours for the transac-

tion to be completed, I used the time to visit 54 rue Lepic.

The baker across the road from number 54 told me that the one-time van Gogh flat was now occupied by a certain Madame Moreau.

"There she is crossing the road. You'll just catch her," said the baker. "If you're lucky . . ."

Madame Moreau was a stalky middle-aged woman with a strong chin and thick biceps. She reminded me of the strong-armed aunt of a Scottish cowboy cartoon character called Desperate Dan. She was at the door of 54 when I nipped across the road and asked her: "Excuse me, madame, my name is Kenneth Wilkie. I am a . . ."

I didn't get further than the word "journalist" when she flashed an icy glare over her shoulder and cut me flat.

"Don't say it!" she said. "I know what you're after. You want to see the inside of my house, don't you? Well, it's my house now. And I don't *care* who lived in it 100 years ago. It's *mine* and I'm sick to death of the likes of *you* pestering me day and night. Even the plaque on the wall outside has been stolen twice in the last five years. Did you know that?"

"I have no intention of disturbing you, madame . . ." I began. But she stomped up the wooden stairs with her shopping.

Madame Moreau, I thought, was probably no more quarrelsome than Vincent was under that same roof during the night-long arguments with his brother. But the present inhabitant's anger had nothing to do with art or literature. Her patience had been teased over the years by tourists following their guidebooks of Montmartre, and all wanting to see inside her home. But I had approached her politely and without presumption. She was just downright rude.

I decided to wait a little, let her cool off, and then try again. Perhaps I just caught her on a bad morning. I climbed to the third floor and pressed the bell. Silence. Then . . .

"I see you. You can't fool me!" She was looking through a peephole. Her voice came like a horn from the other side of the door.

"I am truly *sorry* to trouble you, madame, but could I just take one photograph of your home. Just one and I'll be out. Gone forever," I said. Baroness Bonger had described Vincent's life with her husband, the girl called "S" and Theo in this flat, and I was determined to see the place as it was today. But the physical reality of Madame Moreau looked like being more than I could deal with. I wondered if I was handling her right. Should I resort to deception and disguise as a plumber, perhaps? Or should I take the cow by the horns? Well, there are limits to everyone's tolerance, as Theo found out under this very roof. I was damned if I was going to grovel to her. Any more abuse and I would return the fire. You never know, maybe that would warm the cockles of her fiery Gallic heart?

"I've had enough Americans knocking at my door," she yelled next.

"I'm Scottish. Not American," I replied, hoping to appeal to the traditional French regard for the Scottish nation.

"Scottish? Where's your kilt then? At home with your bagpipes, I suppose?"

"In fact, yes. You're right for once. Now if I come back with my kilt on and serenade you with my bagpipes, will you let me take a photograph?" I asked.

"I didn't know Scotsmen used cameras," she replied.

"Oh yes. Since 1835," I informed her. My patience had officially ended. "I still keep one up my kilt for emergencies. It has an automatic exposure. But it's very sensitive . . . so I would appreciate if you kept out of the picture. . . ."

That did it. She flung the door open, a formidable sight with face beet-red. I could see right away that she hadn't changed her mind about letting me in. She let me have it

instead. As I turned to run down the stairs, she clouted me over the head with a loaf of French bread—a well-fired loaf, the force from which knocked me off balance. I slithered down the stairs clutching envelope and camera-bag. And she was not one for taking prisoners. She heaved down the stairs after me, shouting and waving her rolling-pins of arms like a discus thrower gone wild. "Get out! Get out!" she yelled after me as I limped down rue Lepic. I was going all right, and very glad to get away, too.

So much for Paris. I had come here to see the apartment at rue Lepic and had failed. There was nothing left to do but collect my money at the bank and leave. Leaving would be hard—it is against my instincts to leave a place without getting what I went there for—but I had no choice. An assignment is an assignment, and my time was nearly up. It was Friday afternoon. I hoped to be in Amsterdam Sunday evening, to try and get a good night's sleep. As soon as my money came through, I got back in the car and started off again.

I drove out of Paris, northward to Pontoise and fol-lowed the River Oise to Auvers where Vincent spent his last months in the care of Dr. Gachet.

While in Auvers, Vincent stayed in a little inn belonging to Gustav Ravoux. Now called Café van Gogh, it is situated directly opposite the Town Hall. As I sat in the café, looking out of the window and collecting my thoughts, I was reminded of Vincent's birthplace in Zundert, which was also opposite a Town Hall. But here it was, in a room upstairs, that Vincent died.

Innkeeper Ravoux's daughter Adeline was often painted by Vincent and, before she died, she described to Dr. Tralbaut how she saw Vincent that evening after he had shot himself. I sat in the café and read the passage in my copy of Tralbaut's book.

Monsieur van Gogh had lunch at midday and went out.

Nobody thought anything of it for he came and went all the time and neither my parents nor I noticed anything unusual about his behavior. But in the evening he didn't return. It was a warm night and, after we had finished the meal, we took the air outside the café. Then we saw Monsieur Vincent staggering along the road in big strides, his head tilted towards his maimed ear. He looked drunk although he never drank at Auvers.

When he came near us, he passed like a shadow, without saying 'Bonsoir' as he always did. My mother said to him: 'Monsieur Vincent, we were worried at not seeing you. What happened?' He leant for a few moments on the billiard table in order not to lose his balance, and replied in a low voice: 'Oh nothing, I am wounded.'

Monsieur Vincent slowly climbed the seventeen steps up to his attic room. When I went to the foot of the stairs, I heard him groan. My father went upstairs then. The door was not locked. He went in and saw Monsieur Vincent lying on the narrow iron bedstead with his face turned to the wall. My father asked him what was the matter. 'I shot myself . . . I only hope I haven't botched it,' replied Monsieur Vincent. Then father saw a trickle of blood coming from Monsieur Vincent's chest. He remembered that he had given the painter his pistol that day. Monsieur Vincent said that he wanted it to scare the crows away from his canvas when he was painting in the fields. The police arrived and demanded to know where the weapon was. But Monsieur Vincent refused to give an explanation. 'I am free to do what I want with my body,' he said. 'Can I have my pipe and tobacco?' "I climbed the stairs myself," said Adeline, "and saw him smoking quietly, staring straight ahead of him."

Was that room still there? Was it open to visitors? I

introduced myself to the present owner of the café, who said he'd be happy to show me the room.

"It's remained exactly as it was in 1890," he said.

We climbed the creaking wooden stairs that Vincent himself had staggered up, clutching his wounded chest, and entered. The only furniture in the tiny room is an old iron bed, a tattered straw chair, a chest of drawers, an oil lamp, the painter's easel, and a little calendar for the year 1890.

Here Vincent patiently smoked his pipe, waiting for the end to come while Theo journeyed from Paris to be with his dying brother.

What happened in Auvers to bring on this final act of self-destruction, I wondered. I pictured in my mind the weeping Theo and Vincent's last words: "I wish I could die now. . . ."

By all accounts it didn't seem to be another attack of insanity that made him shoot himself. When Vincent arrived in Auvers he had written to Theo: "I feel completely calm and in good condition. Since I gave up drinking, I do better work than before."

I stood silently for a few minutes in that damp attic room where Vincent died. A deep depression began, not surprisingly, to fill me. Thanking the owner, I walked out of the café into the sun. I passed the low thatched cottages by the placidly flowing river, walked up the well-trodden steps linking streets on different levels, under the flowering chestnuts, along the white dusty roads that cut through the patchwork of tilled soil and ambled in the luxuriant gardens. Vincent had painted them all. And by the time he had been in Auvers for a month, he had also made portraits, not only of Dr. Gachet, but of the doctor's daughter, Marguerite, playing the piano.

In Provence, Dr. Tralbaut had told me that back in the 1930s he had heard about events leading to Vincent's death that involved Dr. Gachet's daughter. This intrigued me. I had found his first love, perhaps Marguerite was his

last. But where was the evidence? The only name Tralbaut could give me was a certain Madame Liberge who was said to have information relating to the affair.

I checked with the Town Hall register to see if Madame Liberge had any descendants still living in the region. The clerk showed me that Madame Liberge had died in 1947, but her daughter, Madame Ginoux, still lived in the family house in rue van Gogh—so called, the clerk told me, because Vincent often set up his easel in that road.

Madame Ginoux had no telephone so I walked to the outskirts of Auvers and found the Ginoux home on a bluff of the river Oise.

As I approached, I could see Madame Ginoux, dressed in a flowery overall, feeding the hens at the door of her house. A woman in her fifties, she had a broad open Gallic face and greeted me at the door without the slightest hint of suspicion or annoyance. I was almost expecting it since my encounter with the muscle-bound madame of rue Lepic.

When I explained my reason for calling on her, Madame Ginoux took me into her big kitchen and over mugs of *café au lait* she told me her story.

"My mother was Marguerite Gachet's best friend. And she was the only person, as far as I am aware, who knew about the love affair between Vincent van Gogh and Marguerite. Marguerite was a proud girl but suppressed by her father. She confided to my mother that Vincent and she had fallen in love with each other and that Vincent wanted to marry her. But the thorn in the flesh was Marguerite's father, Dr. Gachet. Though an advocate of free love in theory, he was strongly against an association between Vincent, who was his patient of course, and his daughter. Gachet forbade Marguerite to see the painter."

So in Auvers Vincent may well have felt himself losing a last opportunity of founding a family. This may have helped to strain his already fragile emotions to breaking point.

Madame Ginoux continued: "After Vincent's suicide,

Marguerite's depression became so serious that she prac-
tically never went out and withdrew more and more. She
was never able to get over the shock of his suicide, my
mother said, and she never married. She became reclusive
and the only times her eyes are said to have come to life
were when Vincent's name was mentioned."

I asked Madame Ginoux if she had any photographs of
her mother. She had a look upstairs and came down with
. . . yes . . . a cardboard box full of old photographs of her
family. She picked out the ones of her mother and told me
to take the ones I was interested in. I thoroughly examined
the contents of the box. There were no drawings. . . .

"You may be interested in this photo of my grandfather,"
said Madame Ginoux, pointing to a sepia picture of an
aristocratic old country gentleman.

"Why him?" I asked.

"Because he is the only person who knew the truth about
where Vincent really shot himself in Auvers," replied
Madame Ginoux. "Our family have always wondered
about all the books that assume, for some reason—probably
the romantic appeal—that Vincent shot himself in the
cornfields. These fields frame the cemetery near where he
painted the canvas of the wheatfields and crows not long
before his death. For some reason the local paper, *L'Echo
Pontoisien*, stated vaguely that van Gogh shot himself in the
fields. And all the biographers went along with it. My
grandfather said he could not understand why no one ever
told the true story. He told me he saw Vincent leave the
Ravoux inn that day and walk in the direction of the
hamlet of Chaponval (which also happens to be the direc-
tion of the Gachet house). Later he saw van Gogh enter
a small farmyard at rue Bouchet. My grandfather said he
heard a shot. He went into the farmyard himself, but there
was no one to be seen. No pistol and no blood, just a dung
heap. The pistol was never found."

"Did your grandfather tell this to the police?" I asked.

"No," said Madame Ginoux. "He said he thought it would complicate matters unnecessarily. He felt it wasn't really important where the man shot himself."

Madame Ginoux insisted that anyone who knew her grandfather would tell he was always to be trusted. "No one has ever asked me about this before," she said. "You may keep these photographs of my mother. They seem to mean a lot to you. As you see, I have others."

Well, surprises till the end, I thought. I thanked Madame Ginoux and walked along rue van Gogh and up the hill toward the cemetery.

Poor Vincent. Every step he took in his turbulent life led to the same deserted heath of unhappiness. With one impossible relationship after the other, he felt he would never find his elusive love nest. And he was right.

I passed the Gothic church which was one of the last subjects Vincent painted. He painted it without a door and included a woman walking away with her back to him. Although dressed in Dutch costume, she appears to represent Eugénie Loyer, Kee Vos, Sien Hoornik, Margot Begemann and Marguerite Gachet. The other road on this canvas led to the graveyard. It was this road I was standing on, the road that Vincent's funeral procession took. As I stood there, I read Tralbaut's account of it.

Many of Vincent's old painter friends went to Auvers for the funeral. The best description was given by the painter Emile Bernard, an old friend of Vincent's from Paris.

. . . On the walls of the room where his body lay, all his last canvases were nailed, forming something like a halo around him. Over the coffin was draped a simple white sheet and masses of flowers, sunflowers that he loved so much, dahlias, and yellow blossoms everywhere. For that was his favorite color, symbol of the light of which he dreamt in hearts as well as paintings. Near the coffin lay his easel, folding stool and

brushes. His friends carried the coffin to the hearse. Theo sobbed ceaselessly. Outside the sun was scorching. We climbed the hill of Auvers talking of him, of the bold forward thrust he gave to art, of the great projects that always preoccupied him, of the good he had done to each of us. We arrived at the cemetery, a small graveyard dotted with fresh tombstones. It is on a height over-looking the fields ready for reaping, under a wide blue sky which he might have loved still —maybe. And then he was lowered into the grave. He would not have cried at that moment. The day was much too much to his liking to prevent us from thinking that he could still have lived happily. . . .

For several weeks Theo was too prostrated to acknowledge the letters he had received. He lost his reason shortly after Vincent's death. After attacking his wife and child, he was admitted to an asylum in Utrecht (the same one in which Margot Begemann had been treated years before) and spent his last weeks in a deep melancholy and state of total apathy. He died in the asylum on January 25, 1891, less than six months after Vincent. He was thirty-three.

In 1914, Theo's widow, Johanna van Gogh-Bonger, arranged for his remains to be moved to Auvers-sur-Oise, so that today the bones of the brothers lie side by side with identical tombstones, the simplest in the cemetery.

The graves are still linked today with ivy, the symbol of fidelity. In death, at least, Vincent is not alone.

I stood at the foot of Vincent's grave and recalled Madame Ginoux telling me that Marguerite Gachet was one of the few friends of Vincent who didn't attend the funeral. Instead, she went the following day and planted two sunflowers by his grave. And till she died in 1949, at the age of 78, she was occasionally seen walking up the hill to the cemetery, a bouquet of yellow flowers in her hand.

Chapter seven
Back in Amsterdam

It was now Sunday, October 1, two weeks and six days since I left Amsterdam. My deadline was exactly twenty hours away. I calculated that if I left Auvers now I could be in Amsterdam by midnight—plenty of time to get a decent night's rest. Fine. I sat in a cornfield and ate French bread and cheese, washed down with the remnants of a bottle of wine brought with me from Paris. The sun was setting and I felt extremely comfortable. No reason, I thought, not to get a half hour of sleep before I set off for my long drive. I stretched out lazily, thinking that it didn't matter if I got back a half hour later. With the cawing of crows sounding faintly in my brain, I fell asleep.

When I woke up, it was nine o'clock and pitch-black out. I had overslept by a mere two and a half hours. I had at least six ahead of me on the road. My unintended snooze had hardly refreshed me. In fact I felt worse than I had when I dozed off. Great. I got into the car and drove off, cursing myself.

Most of that drive is a blur in my memory. I reacted numbly to road signs and other cars, keeping my eyes ahead of me in a glazed stare. The only thing I remember well was what I had been blessed in avoiding before—

about ten miles from Amsterdam, wouldn't you know, I had an accident. Weekend traffic was heavy. There was a hold-up on the motorway and I couldn't brake in time to avoid plowing into the back of the car in front of me. No one was hurt, but my car got the worst of it. The hood had a strange twist to it and the fan belt was jammed. I called the highway distress service, the Wegenwacht, and got a tow into town. So, after all the miles and memories, I limped back home with my tail between my legs. It was about four o'clock on Monday morning when I flopped into bed. I set my alarm for eight and crashed into deep sleep. For the first time since I had found the drawing, I didn't sleep with it under my head.

Eight o'clock seemed to come about ten hours too early. I turned the alarm off and sat up. Every cell in my body told me to go back to sleep but I was determined to keep my deadline. I would be at my desk by nine if it killed me—and for the moment there was a good chance that it would.

I drove to work, fearing that another collision on my bicycle might be disastrous for the photographs and drawing. When I arrived at work, everyone was waiting for me. They had heard about my discoveries and were eager to see what I had. Once again I told the stories of the drawing and Mrs. Maynard and Dr. Tralbaut and Paris and everything else. I was getting a little blasé about the whole thing, but their interest revived my own. I had to caution them from jumping to conclusions about the drawing—exactly as I had done when I discovered it. I found myself reliving certain parts of the story as I told them, and with all this attention I was beginning to feel like some important person.

Our discussions were interrupted in mid-morning by a telephone call from London. It was Vernon Leonard, the editor who had so wanted me back in the office first thing that morning. He was surprised to hear I had made it. The last time I'd spoken to him was on the phone in England,

when he'd tried to dissuade me from going down to Devon.

When I told him what I'd found there, on that trip that he didn't want me to make, he answered briefly and with a bitter tone in his voice.

"Yes, I've heard all about it. But look, it doesn't mean anything till I've got a letter of authentication on my desk. I leave that to you, it's your story. But I don't want you wasting your time in museums, hear? You've got a story to write, and you're a slow writer. You know how long it takes you to get copy out. The research is complete now, it's just a matter of writing it up."

Vernon's words of encouragement and congratulation made a refreshing change from the reactions of the others.

But sound as his advice was, I couldn't help paying one more visit—to the van Gogh Museum, where my travels had begun. The people there had helped me so much, and now I wanted to share with them my excitement. After the telephone conversation with Vernon, I managed to extricate myself from the rest of the staff and drive over to the museum. Amsterdam was at its autumnal best—the air rich with enveloping light.

Once at the museum I went straight to Emile Meijer, whose last words to me before I left had been: "You never know what you'll come back with." What would he think of my loot? I was a little nervous as I knocked at his door.

When I entered, he rose from his chair and greeted me warmly. I don't think he expected to see me again. He asked me how things had gone, and whether I'd seen Tralbaut, and whether Chalcroft had anything interesting to tell me, and a half dozen other rapid-fire questions. We both sat down and I began to tell him what I'd done. He was interested to hear about it all, but when I showed him the photos of Eugénie and the drawing, he nearly fell off his seat.

"This is incredible," he said, "I'm flabbergasted." He pulled a book off his bookshelf to compare the drawing of

87 Hackford Road with other drawings done by Vincent during his stay in London. Magnifying glass in hand, he looked first at the drawing, then at the book. Back and forth, book to drawing, his head moved rapidly but carefully, knowing what it was looking for. Finally, after a few very long minutes, he lifted his head.

"Yes, I'm sure this drawing was done by the same artist."

A small tidal wave of optimism momentarily engulfed me. It was quelled rapidly when I reminded myself that the drawing had to be officially authenticated. I asked Meijer about the procedure to follow.

". . . Mm . . . That's a difficult one," he said, looking silently out of the window for a long time. "In your case, I suggest Dr. Hans Jaffé. He is Professor of Art History at the University of Amsterdam."

"Shall I just write to him?" I asked.

"No, you must approach the Institute of Surveys and ask them if they will appoint Jaffé to give an official assessment," advised Meijer.

"Why don't we go upstairs and see Dr. van Gogh? I think he is in his office, and he would surely like to hear about what you've done."

I agreed, of course. Seeing him would close up the fragile chain of links in Vincent the elder's life: the day before I had stood in front of the Engineer's father's grave in Auvers.

The distinguished-looking old man was sitting at his desk in the office specially reserved for his use. Whatever he was doing, he gladly dropped it to talk to us. Once again I described what I had done and where I had been. And once again my audience was appreciative. Van Gogh was particularly intrigued by the fact that biographers had till now referred to Vincent's London love as Ursula and not Eugénie. "I think when my mother heard about Vincent's affair from Theo she probably confused the names of

Eugénie and her mother. It simply proves that there is always more to learn about van Gogh's life."

Van Gogh asked if he could see the drawing, which Emile Meijer had left downstairs in his office. As we walked down to see it, we were joined by Lily Couvée-Jampoller and Loetje van Leeuwen. Apparently word had quickly got around the small museum staff that I had brought back something interesting, and they all wanted to see it. Once again I was telling the story of Paul Chalcroft, Mrs. Maynard, and the boxes full of photographs. I began sounding to myself like a broken record—but at the same time I was refining my story-telling abilities. In the back of my mind was the story I would soon have to write up for the magazine. After answering questions and chatting for a few minutes, I excused myself to go off to the Institute of Surveys, to see about getting an official assessment.

Before I left, Meijer, Loetje van Leeuwen and I took the drawing around the corner to the restoration department of the Stedelijk Museum in Paulus Potterstraat. The drawing was covered in coffee or tea stains and they wanted to ask the chief restorer what he thought the chances were of having it cleaned up. He picked the drawing up and examined it closely.

"Looks like a silverpoint to me," he said. "The cardboard has been prepared with chalk, and that makes cleaning difficult. But it might be worth a try. By the way, who made the drawing?"

"We think probably van Gogh," replied Loetje van Leeuwen.

The restorer stiffened visibly. His hand shook. He put the drawing back down on the table, took off his glasses and wiped them with a large handkerchief produced from his breast pocket. Then he picked up the drawing again, looked at it for a minute, and spoke.

"No, I wouldn't try to clean it. The stains are not very big, and they don't endanger the drawing. And besides," he

lowered his voice a little, "it's not worth the risk. Good afternoon. Thank you for showing me the drawing."

From there my companions went back to the museum and I set out for the Institute of Surveys. The restorer's reaction to the thought that the drawing in his hands might be a van Gogh amused and impressed me. After all, I had been using it as a pillow for a couple of weeks. Anyway, I didn't mind the tea stains. I imagined that Vincent was so nervous when he presented the drawing to Eugénie that he spilled his tea all over it.

Leaving Dr. Meijer and Loetje, I went next to the office of the Institute of Surveys and filed my request. A few days later I was informed that I could take the drawing to Dr. Jaffé at the university.

Jaffé is an amiable little man, scurrying about his room like a busy hamster. I told him of the events that led me into Mrs. Maynard's living room in Stoke Gabriel and about the uncovering of the photographs of Eugénie Loyer and her family. Then about the drawing. He listened intently but without expression.

When I had finished, he began to examine details of the drawing with a magnifying glass and, like Emile Meijer, compared the sketch with others done by Vincent during his stay in London. "Very interesting and a fascinating story. But that's all I can say at the moment."

"How long before you can give me an official verdict?"

"Well, as usual I'm up to my ears in work. It might take a few weeks. But I'll try to have a decision for you as soon as possible," said the professor, giving me a wink as I left. What did that mean? Had Jaffé made up his mind already? Or did he just have a nervous twitch?

In the next days things were relatively quiet. I spent nearly all my time sorting through my notes and trying to figure out what form the article should take. Finally I began writing. The basic problem was to adapt my findings to the chronology of Vincent's life. I discussed it with

Vernon, who was helpful when you sought his help, and finally decided to weave the people I had met into the story of Vincent's life story. Apart from the main article, which totaled nearly 8,000 words, I wrote separate pieces, about 4,000 words in all, on the sketch discovery, the van Gogh Museum, the reaction of experts, Paul Chalcroft the London postman, the Engineer Dr. Vincent van Gogh, the film in Arles, Dr. Tralbaut, and a story about plaques in Paris and London.

The van Gogh issue was scheduled for February the following year. Volume 8 number 2 was the 75th issue of *Holland Herald*. It turned out that of the forty editorial pages in the issue, twenty-eight were related to van Gogh. The main feature on his life occupied twenty-two pages and the article was illustrated by some of the photos I had taken myself, some of the ones I had found, and others that I had selected from the archives of the van Gogh Museum.

The piece that had to wait until last before it could be written was the discovery of the sketch. It hinged on whether the drawing was authenticated as an original or not. As the copy deadline approached, I still hadn't received a letter from Jaffé.

Nearly every day I had been phoning him to find out if he had finished the examination. Once he had been sick, other times he had been overwhelmed with work. It was always "Next week, Mr. Wilkie." Finally I went to see him and he gave me his profuse apologies again. "I promise to let you have it at the end of the week," he said. "Come back on Friday at 4 PM."

At 3:55 PM I was there, pacing up and down outside Jaffé's door like a father-to-be, trying in vain to distract myself by thinking about other things and talking to students. Jaffé scurried up the stairs. "Ah! Hullo," he said. "Come in. Come in. Sit down."

I felt like I had on my first appearance in an amateur dramatic society years before back in Scotland. Playing

the very minor part of second soldier in Oscar Wilde's *Salome*, I failed to bring John the Baptist's head on stage. The third soldier had mislaid the cabbage.

"I've been so busy," said Jaffé yet again. "I'm so terribly sorry it's taken so long. I really am."

"That's all right," I said. Looking through the window at the last of the autumn leaves hanging delicately on the branches outside, I thought of the trees on the drawing outside 87 Hackford Road. I braced myself to pop the question.

"Wh-what conclusion did you come to?"

"See for yourself," he said, handing me his report.

My eyes raced off the edges of the pages and finally settled on the last paragraph. It read:

On the grounds of topographical evidence, the origin of the drawing, but especially on the grounds of the style in which this drawing has been made, like the two above comparisons, I do not hesitate to accept the drawing shown to me as a work of Vincent van Gogh from his London period 1872–1873.

Amsterdam, Dec. 14th, 1972. *H. L. C. Jaffé.*

Professor of Art History or not, I could have kissed Jaffé. I sat silently for a while with a lump in my throat and then asked him what he had taken into consideration in making his judgment.

"I was quite convinced when I saw the way he drew the top part of the lamp-post," said the professor. "There is the same attention to detail shown in other sketches he did in London as a young man. But it is not drawn exactly in the silverpoint technique, as you were told. True, the paper was prepared with chalk, but the drawing has been made with a pencil. If you hold it at a certain angle, you can see the lead shining. Vincent has heightened the drawing with white in some places. I didn't know that he had ever used

this technique. It's a truly remarkable find. Congratulations."

We shook hands and I left. As I walked down the corridor, my mind flashed back to the living room in Devon, to the cardboard box, the speculation and the doubt. I relived those doubts vividly; they had always seemed perpetually at war with the anticipation of success. Try as I had not to believe anything about the drawing, I had never in my heart considered that it could be anything but a van Gogh. But the rational side of my brain told me not to believe it.

Now, with the letter of authentication in my hand, all doubts were resolved. Back in the office I showed the letter to my colleague Rick Wilson, who was doing the layout. After congratulatory handshakes I left the letter with him and the other people who had gathered round, and went to phone Mrs. Maynard. Her reaction was nearly as ecstatic.

"Oh Ken, how marvelous. It's too good to be true, I'm so excited for you. But what happens now? Should I give the drawing to you, or sell it, or what?" I told Mrs. Maynard I would investigate the different possibilities that were open to her. But in the meantime, could she possibly keep the good news to herself?

"Oh, of course, Ken. I've still only told one or two people about any of this."

Next call was to Vernon Leonard, who had gone back to England, where he spent quite a lot of time in those days. I told him of Jaffé's verdict and his response was characteristic:

"Very good Ken. But now we've got to get that last story done. You know what a slow writer you are. I've given you more time for that article than anyone else would need."

"Of course, Vernon. I'll get to the typewriter immediately." No point in arguing with him.

Next call was to Meijer. He was delightfully blasé about the whole thing.

"I told you so, didn't I?"

"You did. Perhaps you could tell me what might be done with the drawing now. Mrs. Maynard wants to cooperate completely with you, but she doesn't really know how."

Meijer said that of course he would like the drawing for the museum. If Mrs. Maynard wanted to place it on display there, there were various ways of doing it. She could sell it, give it as an outright gift, or give it on loan, for two years, with an option for renewal. Otherwise she could sell it privately or at auction.

The idea of an extended loan seemed best to me. In this way the drawing would still be Mrs. Maynard's property but would be on public view alongside Vincent's other works. In the meantime it would increase in value in case Mrs. Maynard ever wanted to sell it.

When I called her back, she agreed to give it on loan to the museum.

The authentication of the drawing was a kind of high point in the excitement generated by my article—at least for me. Word got around and people I didn't know were coming up to me at parties and congratulating me. The magazine had people phoning from many countries wanting to know about it. Things were buzzing for several days.

I, of course, still had the last article to write. This was the article on the discovery of the drawing, and it was by far the hardest to write. It was the only one in which I had to treat myself as a participant in the events I was describing— something which, as a journalist, I was completely un- accustomed to.

At last everything was written, and only design and production of the magazine remained. We worked hard all through November designing the issue and sent it off

to the printers around the beginning of December. Production was complete by Christmas, just in time for the holidays, which in Holland last several days. I had planned to see my mother in Scotland, and was eager to get out.

Christmas in Scotland is, at least in my family, a cozy ritual. The family—in my case, mother, aunts and uncles—chatter over rattling tea cups, snooze in front of the open fire, and eat a grand meal of turkey and Christmas pudding. By contrast, New Year—called Hogmanay—is a festive time. And for me it was never more festive, more joyous. It lasted for days, days of going from house to house and friend to friend. We sang, danced, kissed whoever was nearby and told stories till we couldn't tell any more. Flutes, fiddles and bagpipes played till dawn every night. And all the time, good malt whiskey flowed like Highland rivers in spate.

It was a perfect way of forgetting about Vincent temporarily. Here in my ancestral home I could leave behind the Borinage, Paris, Arles and St. Remy. I began once again to feel my old self returning—a self that seemed to have been taken over by the Dutch painter whose life I had been researching. The only times I worried about Vincent were when some people whom I told of my assignment said they thought I was starting a little to look like van Gogh. The beard, a wild stare in the eyes. . . . I laughed it off, but I was to hear this again.

On the way back to Amsterdam, I met Vernon in London and together we went down to see Mrs. Maynard in Devon. We invited her, and her husband and daughter, to come over to Amsterdam for a press conference, planned for February 1, at which she would officially present the drawing to the museum.

The press conference had been Vernon's idea—a good way of promoting *Holland Herald* as well as the museum—but Dr. Meijer, the museum director, had been even more enthusiastic about it. He immediately offered the museum

as a place to have it, even though the museum was not yet open to the public. Naturally, he was eager to have the drawing hanging there when it opened.

Everyone had a good reason for wanting a press conference, but it was all pretty surprising to me. I had figured, well, I've found a drawing and it's all very exciting, but that's the end of it. I had done my work, now it was time for the next assignment. I was wrong. My work may have been over, but everyone else was just beginning to figure out how to make the most of what I'd found. Still, I tried as much as possible to ignore the commotion and get on with my work. During the weeks prior to the press conference, I worked on new articles, and they took most of my time. But even during that time my mind was occupied, even when I didn't know it, with research on Vincent. Usually after I've seen an article printed and bound in the magazine, I simply throw away my notes. This one was different. There were questions in those notebooks that continued to perplex me, that kept me awake at nights. How could I possibly turn my back on them?

My problem was not merely curiosity but obsession. Journalistic concerns had turned into personal concerns, and I was finding it impossible to extricate myself completely from Vincent's life. Not that I idealized the man—I was aware that the greatness of his art was more than matched by the seriousness of his personal flaws.

For the few weeks before the press conference I thought continually about Vincent, about what it was that drew me to him. I thought about my own past far more than I do ordinarily. My childhood had been a pretty lonely one, my father dying when I was eleven, my mother being frequently in unstable mental health, school providing little comfort and not much interest. My happiest times I spent with friends in the Highland foothills north of my hometown of Dundee. There we would fish for trout, explore forests and isolated mountains, follow crystal rivers to their

source and watch otters play in the pools of freshly melted snow. But, back home, it was all depressing again. I quit school at seventeen and planned to leave home, but a wise uncle convinced me to stay and get a lowly job in a bank. That lasted for two years of misery, relieved only by camping trips. At nineteen, in 1962, I left home for London.

Since then I have moved around Europe quite a lot. I've worked in fruit markets, Coca Cola factories, lumberjack camps in Sweden, piano bars. It took me a long time to get to journalism, a time spent searching for what I really wanted.

Vincent, too, was a mover, a searcher. In his short life, he lived in over twenty places, and tried art dealing, teaching and the church before he discovered his great vocation. In the weeks I spent pondering my fascination with him, I thought that it must be our common restlessness and rootlessness that drew me to him so strongly.

But the words of the Engineer, Vincent's nephew, came back to me. "What happened in Vincent's life happens to us all. . . ." I was fascinated with him, true enough, and there were broad similarities between us, but none of it was unique to me. The fascination came out of the universality of his genius and his suffering. There was no essential difference between me and the millions of people who love his work from postcards and posters. The only difference was that I, because of my involvement in the article, had had a greater opportunity than most to explore the man's life. I had got a feeling of character from visiting his many homes, from reading and re-reading his letters and a biography, from talking to people who had a connection— if only a slim one—with the man himself.

Discovering a van Gogh drawing was incredibly exciting —needless to say—but I didn't expect to find another one. (Of course, I hadn't expected to find one at all.) In fact, the drawing was not even the most important part of my journey. More than anything else, it was the people—the

forgotten people with stories to tell—that I wanted to search out. I had found that actual living connection with van Gogh was still barely within grasp. I wanted to exploit that as far as possible. There were questions I had about several periods of Vincent's life, about his relationship with a prostitute named Sien in The Hague, about his illness, about his time in Paris. Perhaps there was someone who could tell me something about these things.

Whether or not I was driving headlong down a dead end, I was resolved to find out. As the day of the press conference drew near, my resolve strengthened steadily. The press conference was the culmination of my first journey, but only the beginning of my second.

There were numerous preparations for the press conference. We assembled a press kit consisting of a copy of the magazine, various photographs, and a press release telling how I had discovered the drawing. The museum provided a room and refreshments.

At the *Holland Herald* there was a general mood of excitement. Everyone gave extra time to arranging things, contacting people, making sure that everything was just right. The day before the conference itself, Vernon and I drove out to the airport to pick up the Maynards, who had flown in from London, and that night we had dinner with them as guests of the Amsterdam Hilton.

The conference was scheduled for 10:30 the next day, and by 10:00 the room was packed. Dutch, British, American, German, and Japanese newspapers and magazines were all represented. Excitement was high—or at least it seemed that way from my vantage point. I was seated at a long table with the Engineer, Dr. Meijer, Mr. and Mrs. Maynard, and Vernon Leonard. I felt like I was on the panel of a TV game show.

Dr. Meijer officiated. He told the story of how I had found the drawing and photographs, sparing no eloquence about either my investigative skills or the importance of the

discovery. He then introduced Mrs. Maynard, who was nervous but calm. The flashbulbs flashed as she officially handed the drawing to him. In return he gave her a framed reproduction of the drawing—in case she forgot what it looked like, I thought.

Everyone seemed interested except one Dutch correspondent who is well known for his vociferous objections to such proceedings. He walked out, shouting: "This is just another publicity trick. I was tricked into thinking there would be more information about the van Gogh Museum." No one paid much attention as he stormed out.

I was looking on rather placidly, thinking how silly it was to pay so much attention to a single piece of paper. Suddenly I became dimly aware of someone nudging me in the ribs. I looked up at Dr. Meijer and saw that he was motioning in my direction. He called me up to the podium and, after thanking me for what I had done, presented me with another framed reproduction—this one of a van Gogh self-portrait. It happened to be one of my least favorite of Vincent's self-portraits, but I was hardly in a position to complain. I thanked him, a few more flashbulbs flashed, and sat down. The ceremony was over.

Afterwards other journalists flocked around to ask me questions. The most common was whether I had tried to take advantage of Mrs. Maynard. "Didn't you think of buying the drawing or making some kind of deal?"

"To tell you the truth, the thought never entered my mind. I followed my natural instincts all along and played it straight. I never considered trying to rob Mrs. Maynard of what was hers."

Several journalists seemed amazed.

After the conference broke up, the Maynards were packed off into a horse-drawn carriage to go on a tour of Amsterdam arranged by Dr. Meijer. I said goodbye and prepared to leave myself. On the way out, I ran into Dr. van Gogh, who was also leaving. I walked with him to his car.

"So, Mr. Wilkie, what are you going to work on now?"

"Various things, Dr. van Gogh. My first long assignment is on the artist M. C. Escher."

"Ah yes, and anything else?"

"Well, I don't think I'm done with Vincent van Gogh yet."

"Oh, you have another article planned?"

"No, just some questions raised by my first article which I would like to explore further."

We reached the Engineer's car and stopped. He pulled his overcoat tight around him to keep out a chilly wind that had blown up. He looked toward the ground as he tried to find his car keys.

"It is good you will do more work on van Gogh. I am always interested in new information about him. Perhaps we will speak again."

"Yes, I hope so."

We shook hands and smiled at each other, and the Engineer drove off.

Neither of us knew it then, but we would indeed meet again. And next time there would not be so many smiles.

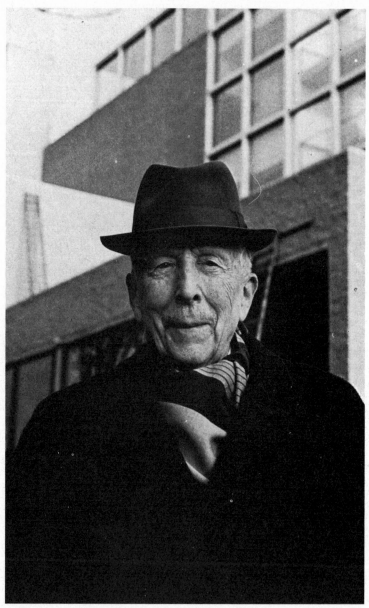

Dr. Vincent van Gogh, the Engineer

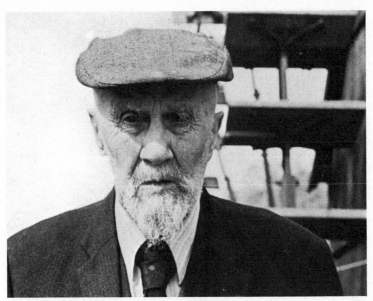

Piet van Hoorn

The mill at Opwetten

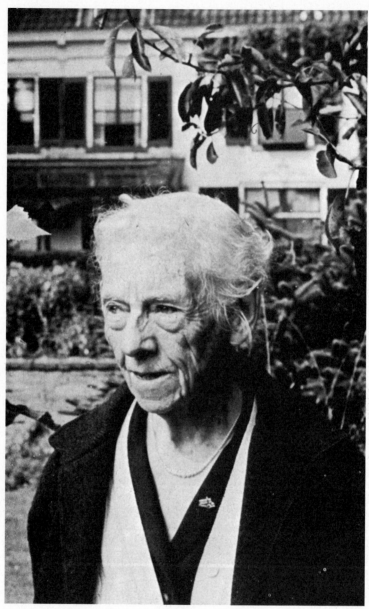

Baroness Françoise Bonger

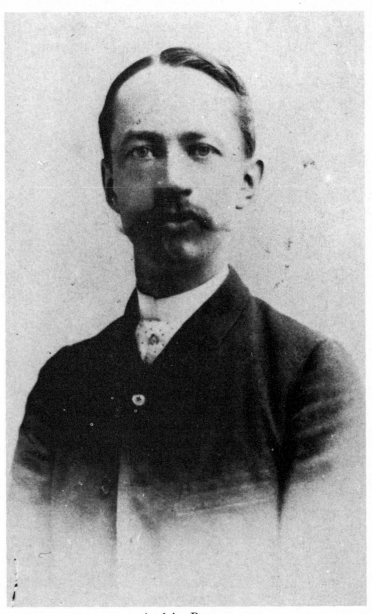

Andries Bonger

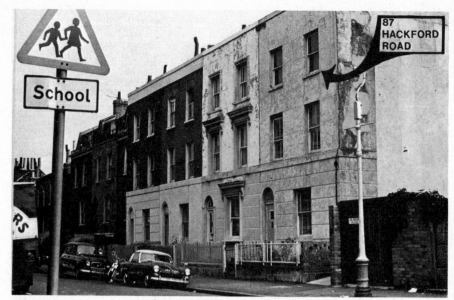

87 Hackford Road today

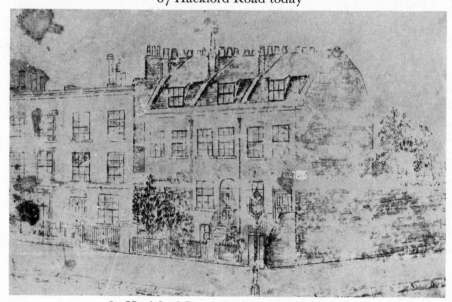

87 Hackford Road, by Vincent van Gogh

Interior of 87 Hackford Road at the time of van Gogh's residence

The same room today.

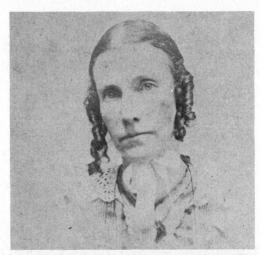

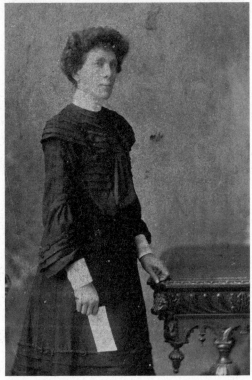

The young Eugénie Loyer (top) and in later years.

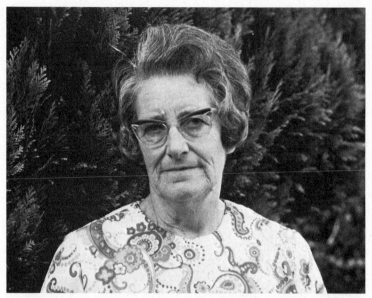

Kathleen Maynard

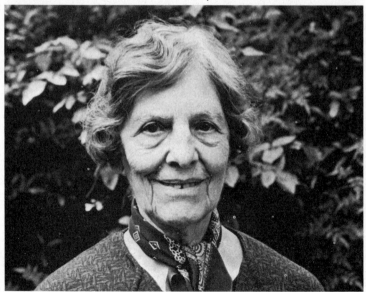

Enid Plowman

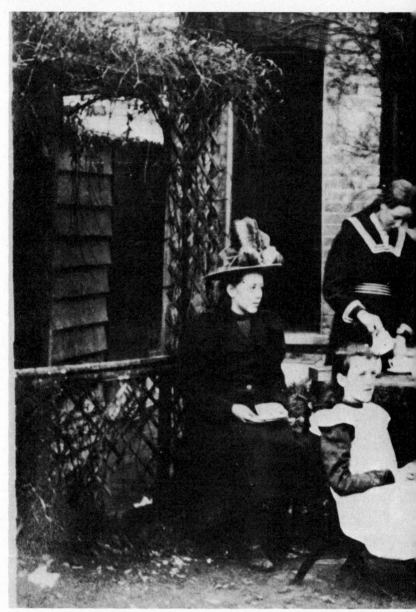

Eugénie Loyer with her family

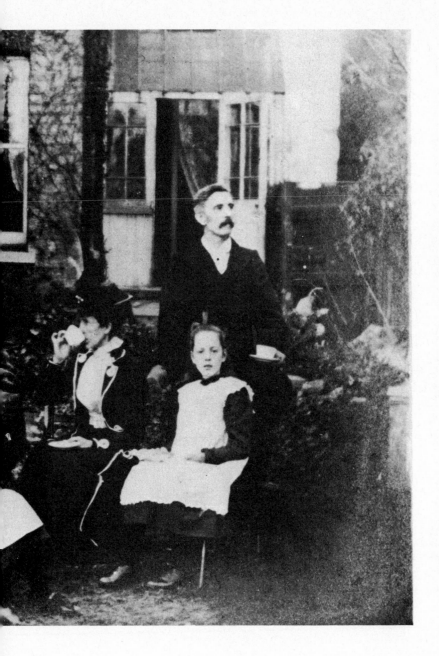

133

Jean-Baptiste Denis and wife

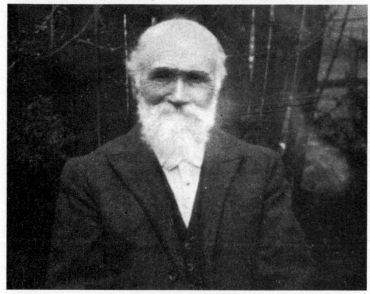

Jean-Baptiste Denis

Jean Richez and wife

The Marcasse

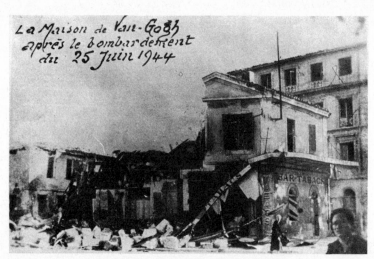

The Yellow House after bombing

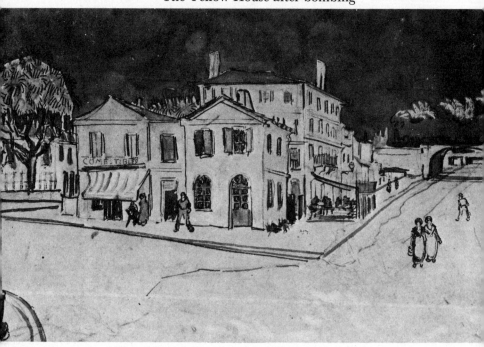

Vincent's painting of the Yellow House

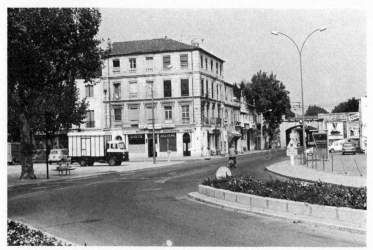

Hotel Terminus

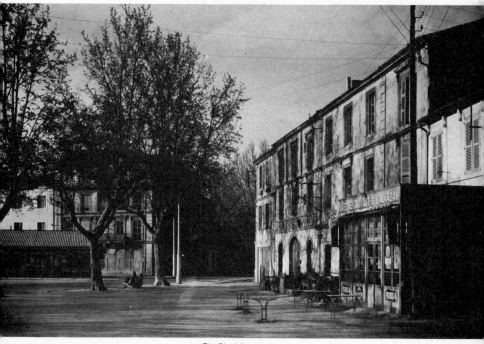

Café Alcazar

View of the asylum

View from Vincent's window

Sister Epiphany

The baths at the asylum

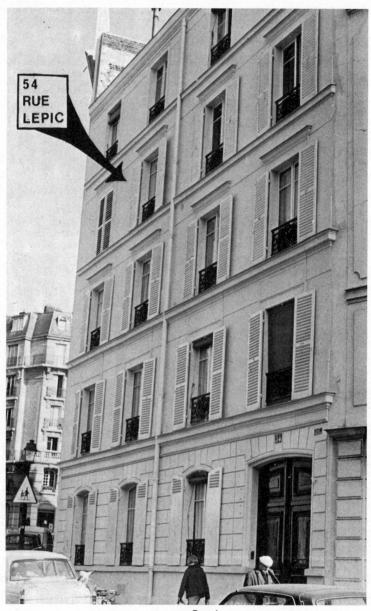

54 rue Lepic

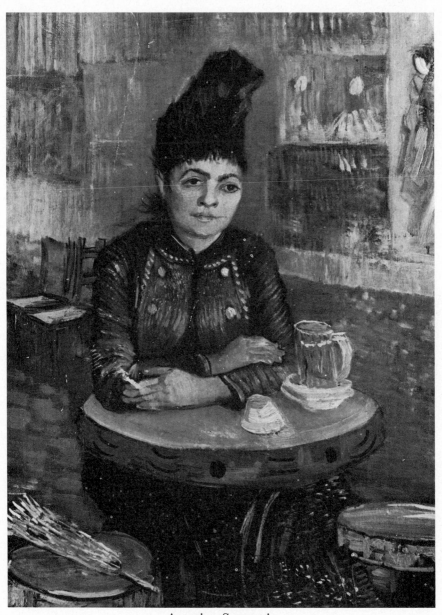

Agostina Segatori

143

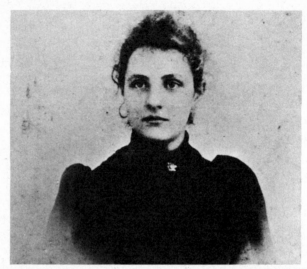

Adeline Ravoux

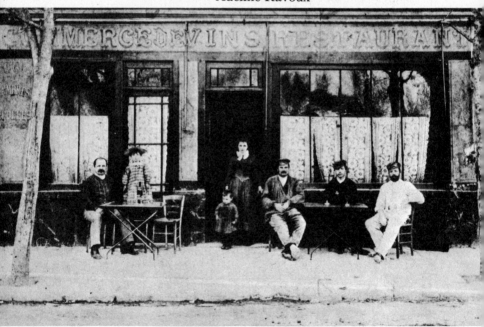

The café where Vincent died

Marguerite Gachet

Two views of the room where Vincent died

147

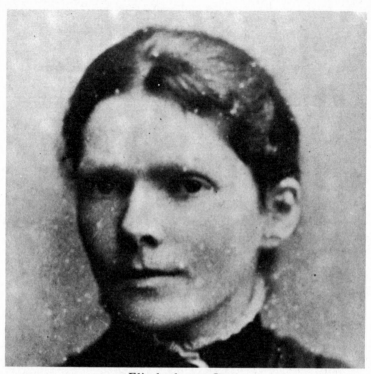

Elisabeth van Gogh

The back of Vincent's Antwerp sketchbook

Dr. Amadeus Cavanaille

relax the nerves, destroyed his health instead of
restoring it. His habit of going almost without
food had made him weaker and more susceptible to
alcohol than Gauguin, who was large and robust.
At Arles Vincent often complained in his letters of
being utterly exhausted.

Moreover, Vincent had caught (syphilis, probably
at Antwerp, and this certainly contributed to his
physical and mental condition. When on top of all
this there was the tension between him and Gauguin,
a mental breakdown was inevitable.

At the hospital, the inner courtyard of which was
later to inspire a remarkable painting and an
interesting reed-and-ink drawing, he was shut up in
the cell allocated to dangerous lunatics, or raving
madmen as they were then commonly called. Vin-
cent suffered something worse and more cruel than
mere confinement. The cell has now gone as a result
of alterations to the building, but we know that its
only window was high up, near the ceiling, and Vin-
cent could not possibly see out of it.

Theo took the first train from Paris to Arles and

no !
where does
Tralbaut
get it from?
V W v. G.

Page 261 of Tralbaut biography, with the Engineer's marginalia

149

Sien with Willem, drawn by Vincent van Gogh

Heb ge noodig ik nog duidelyker te alles verklaren
zekere — Ge zegt het zelf dat gy wenscht ik de
vrouw ~~absoluut~~ verlate ja absoluut verlate
Goed, maar dat wil of kan ik niet doen
verstaat ge, vriend, en het ware valsch indien
ik zulks deed — ik denk aan een oud Bybelwoord
"verberg uw aangezigt niet voor uwen naaste"
Vierkant weg zeg ik u nu Neen Theo
(wil gy nu presumeeren ik dit of dat wel doen denk
gy er van precies wat ge wilt ik zal doen zoo als ik
doen zal D.v.)
Ik weet nu zeer wel dit een teer punt is dat
zamenhangt met het financieele. Niet in den
den waarop gy in uw brief ~~zuelt alleen~~ maar in de eerste plaats
nog in een anderen. Indien ik geld van
u accepteer en doe iets waar gy u tegen zegt
tegen verklaart zou dit scheef zyn ik heb altzd
met u gesproken openharty over alles en
juist my getoond zoo als ik was getracht
~~naar ik heb niet getracht zonder u iets te zeggen~~ ~~dit zou ophouden en~~
naar opregtheid. Goed waar wy nu in ons
privé leven elkaar niet meer zouden kennen
zou onze positie als scheef krygen. En daar
bedank ik voor.
Ik heb me uitgesproken over Pa ik heb
me uitgesproken over te wat dezen zomer
aangaat waarom? om te over te halen
tot myn zienswyz? — Neen maar omdat
ik ~~weet~~ het valsch van my zou vinden ik
zulke dingen in my op sloot. Een verrader
ben ik nu eenmaal niet en indien ik tegen
iemand iets heb zoo zeg ik het en voor de gevolgen
vrees ik niet al kunnen die serieus genoeg
zyn.

A letter from the Hague period. The beginning is missing

151

Willem van Wijk

Mies Bouhuys (extreme right) and Ed Hoornik (seated)

Willy van Wijk

Part Two

Chapter eight

Two Doctors

For the few weeks following the press conference my time
was completely taken up by various articles for the maga-
zine. The article on M. C. Escher involved some travel
around Holland and elsewhere, and other short pieces
required as much time going from place to place in Amster-
dam as sitting in front of the typewriter. Between traveling
and typing, I had no space for Vincent.

But I continued to think about him. Every time I sat
down in my office at home, I saw a list of the questions I
wanted to go into further. In a burst of activity one after-
noon I had typed them neatly out and pinned them to the
wall. They sat there for days, reminding me silently of the
task I had set myself—and which I was now unable to
perform. Often I would lie awake thinking about what I
wanted to do. Finally I resolved that I would give every
weekend to Vincent. There was no other way I was going
to get the thing done.

The first question on my list concerned the change
Vincent had gone through between the time he lived in
Nuenen, in 1884, and his stay two years later in Paris. Old
Piet van Hoorn had described a friendly if eccentric
fellow, while Baroness Bonger had reported her husband's

description of someone virtually impossible to live with. They seemed to be talking about two different people. What had caused the change?

The explanation must, I thought, lie mainly in the three months or so that Vincent spent in Antwerp between his time in Neunen and his time in Paris. Had something happened to him there to cause this fundamental change in his personality?

On my first free weekend, I went to the van Gogh Museum archives to read through the letters and sift through any documentary evidence I could find. I wanted to assemble in my mind as complete a picture of Vincent's stay in Antwerp as I could.

Vincent had left Nuenen in less than happy circumstances. His father died in March of 1885, and the event had a profound effect on him. He had been touched also by rumor and scandals: Margot Begemann, the girl next door, had fallen in love with him and tried to commit suicide. In August, the local Roman Catholic priests had criticized him severely for getting "too familiar with people below my rank"; one even went so far as to offer money to prospective models if they would refuse to be painted. And Vincent had been accused of having sexual relations with Gordina de Groot, a member of the family in his great painting *The Potato Eaters*.

So, late in November of 1885, Vincent went to Antwerp. His earliest letters there describe with delight the harbor area, where he spent time watching the bustle of daily life, talking to "various girls who seemed to take me for a sailor," and observing the light on the docks and buildings. He had his usual money problems—models were expensive and the bill for his paints was "like a millstone around my neck"—but he worked hard and had the opportunity to study the paintings that could be seen in churches, galleries and museums. Antwerp is the city of Rubens, and Vincent studied his work closely.

But as the letters continued, Vincent's mood changed. He spoke increasingly of his healty, which was not good. He confessed to Theo that he was "afraid of dying before his talent was recognized," and that he was "afraid of madness." He produced two macabre pictures: one a painting called *Skull with Cigarette*, which shows a skeleton smoking, and another drawing of a hanging skeleton. Moreover, his first self-portraits date from this period—they are dark and gloomy in atmosphere, and seem to reflect a morbid introspection.

Perhaps Vincent's ill health was connected with this morbid self-awareness. Perhaps the key to the change in his personality was to be found in his illness. This was the line I decided to follow.

I soon discovered that I was hardly the first to try and figure out what Vincent's disease was. Among the numerous hypotheses that have been put forward are one or another form of epilepsy, schizophrenia, dementia praecox, meningo-encephalitis luetica (whatever that might be, I thought), cerebral tumor, hallucinatory psychosis, chronic sunstroke and the influence of yellow, dromamania, turpentine poisoning, and hypertrophy of the creative forces.

What was I going to add to this forbidding array of diagnoses? I had to look up half the words in a medical dictionary. At least I knew that some of them couldn't have anything to do with Vincent's behavior in Antwerp: chronic sunstroke is hardly a danger in Belgium. Nonetheless, the multitude of medical explanations for Vincent's condition was baffling.

As I sat in the van Gogh Museum wondering where to go next, I remembered something Dr. Tralbaut had told me in Provence. When he was doing some research on Vincent, he had come across the name "Cavanaille" scrawled on the back of one of his Antwerp sketch books of 1885. Tralbaut had not investigated the matter very intensively himself, but he had noticed what seemed to be consultation

hours scrawled with the name. From this he had supposed "Cavanaille" to be a doctor.

I decided to check out this reference for myself. I asked to see the notebook and it was soon produced. Sure enough, there on the cardboard back was written: "A. Cavanaille, rue de Hollande 2, consultations: 8 a 9, 1½ a 3." Tralbaut was surely right in thinking that Cavanaille was some sort of a doctor.

I leafed through the rest of the notebook to see whether it might have anything to supplement this rudimentary lead. And it did. On one of the pages is written: "demain midi huile de ricin. Alum 20c pinte ou ½ temps à autre 10h. bain de siege." This translates roughly as: "Tomorrow noon castor oil. Alum 20c of ½ time to time 10AM sitz bath." And written at the bottom of the page was the single word "Stuyvenberg."

The castor oil must have been for the stomach ailments of which Vincent frequently complained to Theo. But he never mentioned the alum and sitz bath, which I knew was a kind of bath used in therapeutic treatment. What were they for? And what was Stuyvenberg? I decided that I had to go to Antwerp to find out.

The first weekend I had free was in mid-March, and I set out early on Saturday morning. The two-hour drive passed quickly as I thought about the question I was going to investigate in Antwerp. A friend who grew up in the city had told me that Stuyvenberg is the name of one of the Antwerp hospitals. It stands at the end of the rue des Images, not far from where Vincent's house (since demolished) in what is now called the Lange Beeldekensstraat. With this lead and the name Cavanaille, I thought for certain I would find something—maybe some hospital records, or reports on Vincent's condition.

I arrived in the city at around 10:30 and went straight to a cafe for a mid-morning cup of coffee. I sat by myself, studying the street map to figure out how to get to the

hospital. I was eager to get my fingers into the medical archives.

Out on the street again, I was heading for my car when I passed a row of telephone booths. It suddenly occurred to me that I was neglecting my customary homage to fellow Scotsman Alexander Graham Bell—why not look up the name Cavanaille in the phone book? It was a long shot, but as long as I was here . . . I went into the nearest booth and thumbed through to the C section of the book.

What I saw took me completely by surprise. There was one entry for Cavanaille. The first initial was A., just as on the back of Vincent's notebook. And this A. Cavanaille was a doctor too.

I didn't register for a moment what I was seeing. Could this be an old phone book? Was the original Dr. Cavanaille still alive? A quick calculation made him about 150 years old if it was the same one. Impossible. No. There was only one thing to do, and I couldn't dial the number fast enough. The phone rang twice and someone answered it. A pause, and then a slow, solemn voice spoke:

"You are speaking with Doctor Amadeus Cavanaille."

It sounded as if he had lived to be 150 after all. I explained who I was and what I was looking for. The slow voice spoke again.

"The Cavanaille you are looking for was my grandfather. My father was a doctor too. I am the third generation—at least the third—of doctors in the Cavanaille family."

He paused, then spoke.

"I think I may have information that could be of use to you."

"May—may I come and talk to you?"

"Certainly, if you wish."

Seconds later I was racing through the cobbled streets of Antwerp to Dr. Cavanaille's office in the rue de Hollande. In my excitement I turned the wrong way up a one-way

street and drove almost straight into the arms of a traffic cop. My heart pounded while he wrote out the ticket. I had never been so enthusiastic about a doctor's appointment in my life.

Dr. Cavanaille's office is in a solid nineteenth-century red brick house. I rang the bell twice and waited for a few moments until the doctor himself answered the door. He is a short, thick-set man in his late fifties with straight silver hair, small eyes and a fine hooked nose.

Cavanaille led the way to his office, a spacious and rather old-fashioned complex of rooms on the first floor. We went into his consulting room and he motioned for me to sit in the patient's chair across from his desk. He went around the desk and sat back in his own creased brown leather chair. Unhooking the stethoscope from around his neck, he started talking.

"My grandfather's name was Hubertus Amadeus Cavanaille. He was born in the town of Oudenaarde, on the river Schelde about fifteen miles from Ghent, in 1841. He established himself in Antwerp in 1883."

I was trying to be polite, but my mind was on other things. I tried to bring Cavanaille around to the point.

"Hmm . . . that would be about two years before Vincent van Gogh was in Antwerp."

"Two years. He came to see my grandfather late in 1885. In fact, he would have sat in the same seat you are in now."

"Then van Gogh was a patient of your grandfather's?"

"Oh yes. Grandfather never talked about it to anyone outside the family. But he did confide in father and me."

I sat on the edge of my seat as Cavanaille began to relate events that took place in this room a century before.

"Van Gogh came to see my grandfather because the dockland was then very near the rue de Hollande, where we are now. Many of his patients were sailors or dock workers.

"Van Gogh struck my father immediately as a strange and unstable character, he said. He never went into many specifics, unfortunately. I don't think he regarded them as important."

"Did your grandfather tell you what he treated van Gogh for?"

"Yes, he did regard that as important. He said he treated van Gogh for syphilis—in an advanced stage. He prescribed alum and sent him to the Stuyvenberg hospital for sitz bath treatments. Van Gogh did not have a bath in his own lodgings. . . ."

I was taken aback by this information. I remembered that Tralbaut mentioned it in his biography, but there seemed to be no proof offered. And somehow I hadn't given his mention of the disease much thought. I would have to look at Tralbaut's book again.

"Did your grandfather say whether van Gogh was cured by the treatments?"

"He could not be cured," replied Cavanaille. "He had not received medical care early enough. And the treatment was not completely effective in those times before we knew about penicillin."

"Would the disease have repercussions on van Gogh later in life?"

"Without a doubt. If you have advanced syphilis now, without having received treatment, your prospects are grim. At that time they would have been even worse. My grandfather said that van Gogh pressed him for details about the disease. He seems to have been worried about himself. My grandfather told him that syphilis could affect the brain and even be fatal. And also that it was thought to be hereditary."

"Do you think it likely that the disease would have started to affect van Gogh's brain by the time he was in Arles, in 1888? As you know, he began to have nervous breakdowns of some sort there."

"Oh yes, certainly. It could have been, at the very least, a contributory cause of his ultimate madness. But there are surely other factors that make the matter too complicated to be explained by a single disease."

"Did your grandfather report anything else of interest that van Gogh had said to him?"

"Well, he did tell us that before he treated van Gogh the painter warned him that he was unable to pay cash. The only way of paying my grandfather was by painting his portrait. My grandfather agreed."

"Where is the portrait now? Do you have it?"

"No, unfortunately the painting has been lost," he replied. "But not by me, I hasten to add. I remember seeing it when I was a boy. It was a small oil signed 'Vincent.' Later in life when I saw the portrait that van Gogh had made of Dr. Gachet, who treated him in Auvers-sur-Oise, I was reminded of the portrait of my grandfather. Van Gogh seems to have appreciated his doctors."

I asked Cavanaille how the portrait had been lost.

"It was inherited by my sister Jeanne," he said. She married a Jewish corn merchant from the Ukraine whose name was Kleibs. They emigrated to England before the First World War, and they took the portrait with them. Neither Jeanne nor the portrait has been seen since.

"I tried to trace her several times, but my efforts have always been in vain. She was last heard of in the 1930s, living in a London suburb called Muswell Hill. But she moved from there without a trace and hasn't been heard of since.

"She had two sons and three daughters. One of the sons was killed in the war while serving with the Canadian Air Force, and one of the daughters, Nadia, was a dentist in Paris. I don't know where she is now. Someone in the family may have the portrait on the wall without realizing what it is. I'd like to know. I'd like to know where my sister is, if she is still alive. . . ."

"But this can't be of interest to you. I think I've passed on everything my grandfather told me about Monsieur van Gogh. I can certainly tell you one thing: I've never had any patients like him. I don't think many doctors have."

After that we changed the subject to the charms of Antwerp, the relative merits of various Belgian beers, and other trivial things. Cavanaille did tell me that I would be unlikely to find any records at the Stuyvenberg hospital, since they had probably been destroyed. But by that time I wasn't so eager to have them anyway. I felt I had found more in Antwerp than I had bargained for, and I was satisfied. After taking my leave of Cavanaille, I set out for the trip back to Amsterdam.

As I drove I thought through what I had learned from Cavanaille. The changes in Vincent's character while in Antwerp seemed to make more sense now. The sudden introspection in the form of those first self-portraits; his preoccupation with death, evident in the macabre skeleton paintings; his fear, expressed to Theo, of going mad or dying before his talent was recognized. These must have had something to do with Vincent's discovery that he had syphilis—and that the disease would inevitably affect his brain.

Perhaps the discovery also had something to do with the personality change between the Vincent of Nuenen and the Vincent of Paris. Had the syphilis already begun to affect his brain?

What surprised me about Dr. Cavanaille's revelations was that Vincent, who was always so open in his letters to Theo, had never mentioned the nature of his illness to his brother. He talked about his stomach problems, his teeth falling out, his weakness—but never gave any hint of this most serious disease. Was he too ashamed of it? And how had I missed other references to Vincent's syphilis?

Immediately upon arriving back in Amsterdam, I looked through my copy of Tralbaut's biography. I knew I had

seen a reference to syphilis somewhere in it but couldn't
remember where. After a few minutes with a glass of beer,
I found it on page 261. And what I found there was more
interesting than a mere reference.

Tralbaut writes: "Moreover, Vincent had caught syphilis,
probably at Antwerp, and this certainly contributed to his
physical and mental condition. . . ." So Tralbaut did know
about it, even though he seemed to place little importance
on it.

What interested me much more than Tralbaut's words
was a hand-written note in the margin of my copy of the
book. The word "syphilis" was circled in the text and next
to it were the words "NO! Where does Tralbaut get it
from?" And the note was signed: V.W.v.G. Vincent
Willem van Gogh. The painter's nephew, the man I knew
as Dr. van Gogh and whom others called the Engineer.

How could the Engineer be so sure of himself about this?
And why was he so agitated by the reference to syphilis?

I took the following Monday off from work and went to
the museum to look through the archives. While scouring
Vincent's letters for further clues about his disease, I found
a passage that might explain why the Engineer was so
edgy about the subject. The passage was in letter 489,
written to Theo when Vincent was in Arles. In it Vincent
reveals that he was receiving treatment from a Dr. Gruby
in Paris for an ailment that must have been syphilis. And
Theo was receiving the same treatment—for the same
ailment.

The letter reads, in part:

What you write about your visits to Gruby has dis-
tressed me, but all the same I am relieved that you
went. . . .Remember how last winter I was stupefied to
the point of being absolutely incapable of doing any-
thing at all, except a little painting, although I was
not taking any iodide of potassium . . . I expect he will

make you promise to have nothing to do with women except in case of necessity, but anyhow as little as possible. . . .

I believe iodide of potassium purifies the blood and the whole system, or doesn't it? . . . Did you notice Gruby's face when he shuts his mouth tight and says— 'No women!' It would make a fine Degas, that. But there is no answering back. . . . It will be the same story as mine, get as much of the spring air as possible, go to bed *very early*, because you must have sleep, and as for food, plenty of fresh vegetables, and no *bad wine* or *bad* alcohol. And very little of women, and *lots of patience*.

It doesn't matter if you don't shake it off at once. Gruby will give you a strengthening diet. . . . I shall not believe you if in your next letter you tell me there's nothing wrong with you. It is perhaps a more serious change. . . .

I looked in the library for more material on the subject of Vincent's illness. Among the hundreds of books and articles, I found the text of a lecture given by Tralbaut to the 1964 French Language Congress of Psychiatry and Neurology. The lecture showed that Vincent's and Theo's mental and physical disabilities were similar in every respect. Moreover, Tralbaut pointed out that one of the younger van Gogh sisters, Wilhelmien, spent much of her life—almost fifty years—in an asylum for psychiatric patients. And in his book, Tralbaut concludes that "the probability of hereditary influences seems to be overwhelming."

Vincent had also told Dr. Peyron at the asylum in St. Remy that his mother's sister was epileptic and that there were many cases of mental disturbance in the family. And Dr. Peyron later wrote: "What has happened to this patient would only be a continuation of what has happened to several members of his family."

The vehemence with which the Engineer had insisted that his uncle hadn't contracted syphilis suddenly made sense. If true it might mean that Theo, the Engineer's father, had also had the disease. And if Vincent's syphilis had contributed to a mental breakdown to which heredity predisposed him, then this too must be alarming for the Engineer. Most worrying of all, if Theo had syphilis in 1888, he might have been suffering from it in 1889, when the Engineer was conceived. . . .

I knew I was on sensitive ground here, but I wanted to ask the Engineer directly about these questions. He wasn't at his office in the museum that day, but I made an appointment to see him there a few days later.

On the day of the appointment I was nervous as hell. I knew I was going to raise a subject about which the Engineer was extremely touchy, and I didn't want to make any trouble. At times I seriously considered canceling the appointment and forgetting the whole thing. Why should I cause him aggravation? I had nothing against him whatsoever. But I forced myself to go through with it. To do otherwise would have gone against my resolution.

So, on March 22, at 10:30 AM, I found myself standing at the door to the Engineer's office. My mouth was dry and my hand shook a little as I knocked softly on the door. I heard a voice ask me to come in, and in I went.

The Engineer was sitting behind his desk, dressed as I had always seen him in a suit and tie. He greeted me with his customary formal politeness and asked me to sit down. We chatted a few minutes about trivial matters, and then I got (too abruptly? I asked myself) to the point.

My journalistic training had taught me that you stand a better chance of finding out about a person if you refrain from telling him everything you know. It's better simply to raise a question and give him an open platform to talk on. For this reason I had decided not to tell the Engineer what I had found in Antwerp.

"I've been looking into a few questions about van Gogh's life, and was wondering whether you might be able to help me with one or two of them. Is it true that Vincent contracted syphilis?"

Dr. van Gogh's reaction was one of surprise and suspicion combined. His eyes narrowed and his mouth seemed to set. He paused for several tense moments before answering.

"No, he never had syphilis. Where did you get that idea?"

"I read it somewhere. A biography mentions it. You're absolutely certain . . . ?"

"Of course I am," he answered rather sharply. "Surely you have something more substantial to ask about."

"What was your father suffering from when he lost his reason shortly before his death?"

The Engineer looked straight into my eyes. The politeness was still there—he is a true gentleman, I thought—but the warmth had definitely disappeared. Van Gogh stared at me icily for a few moments, then looked away. A few more moments of silence. I repeated the question, rephrasing it a little to make it slightly less abrupt.

Still looking away, the Engineer made a peculiar gesture. With his arm bent in an awkward stiff position, he pointed between his legs. He looked rather embarrassed.

"Water," he said, as if the word were difficult to pronounce. "He had difficulty passing water."

When I asked what the cause of the difficulty was, he shook his head.

"I don't know. Don't ask me."

"Was there any connection between your father's illness and Vincent's?"

Again he gave me that look, unswerving as a laser beam aimed right into my eyes.

"None whatsoever. There is no evidence for that."

"I see. Some writers have suggested that there may be some evidence for the existence in your family of hereditary insanity. What do you make of that?"

166

"Nonsense."

"You discredit the idea completely?"

"I do."

Well, this was getting nowhere. The Engineer was determined not to give me an inch on anything, and there was no point in staying around to get negative answers to all my questions. I thanked him politely for giving me his time and left.

Riding my bicycle back to the office, I thought about the stone walls of denial with which Dr. van Gogh had answered my questions. I could understand his reluctance to acknowledge a history of venereal disease and mental illness in his own family. I could appreciate that his uncle, and his father as well, had been written about ceaselessly by scholars and critics of all kinds. The burden of a famous family is never an easy one to bear.

But Dr. van Gogh's refusal even to consider these things infuriated me. His family fame is a burden, yes, but it is also a serious responsibility. He cannot, I thought, be selectively interested in new information, listening only to whatever conforms to the view he would like people to have of his family. I could not help comparing his attitude toward my questions about venereal and mental disease to the recent claims of a cover-up concerning the burglary of the Democratic party national headquarters at the Watergate apartment complex in Washington, D.C. There, it seemed, someone very powerful was trying to conceal facts about something unpleasant to them. The Engineer was trying to do the same thing. And while the two cases were hardly comparable in importance, the basic principle was identical in both. I resolved that I was not going to let myself be intimidated by the personalities involved. I would pursue whatever questions interested me about Vincent, regardless of how much his nephew, the Engineer, opposed me.

For me, the discovery that Vincent had syphilis was fascinating, important, and exciting. But it was hardly a

skeleton in the closet, as Dr. van Gogh seemed to regard it. Pedaling along the canalside streets of springtime Amsterdam, I wondered what other skeletons I would uncover.

Chapter nine
The Forgotten Niece

Work for the *Holland Herald* once again took over my time, and I was getting nowhere. I did manage to steal some time for Vincent in Paris, but what I did there came to nothing. It was not until a few weeks after my trip to Antwerp, in early April, that I heard about something that set me once again on the van Gogh trail.

At a small party in Amsterdam, I met a fellow named Gary Schwartz, an American who had moved to Holland and set up a publishing house to publish works of art history. I told him about what I was doing and he mentioned having heard of a niece of Vincent's who was living destitute in France somewhere. He couldn't remember any details, but he did give me the name of an Amsterdam lawyer named Benno Stokvis who was said to have information.

I called Stokvis the following morning. He was polite but insistent: he had no desire to talk to me or anyone else about the van Gogh family. He sounded afraid of something or someone—I wondered what it was. Unfortunately, he has since died. His secret has gone to the grave with him, as far as I know.

Stokvis' silence left me with nothing but my curiosity. It

forced me back to my old territory—the archives of the van Gogh Museum. There I was able to find only one slim clue: a reference to an article in a Marseilles newspaper called *Le Provencal*. The subject of the article: someone named Hubertina Normance van Gogh. Was this the niece that Gary Schwartz had heard about? There was no way of finding out, because the article was not in the museum library.

But the name Hubertina did ring a bell. Wasn't that the name of one of Vincent's sisters? A quick check in one of the library books told me it was Elizabeth Huberta. I considered trying to ask the Engineer about this affair, but decided it would be a bit premature to do so now. Instead, I went back home and put a call through to the offices of *Le Provencal*. The reference I saw to the article said it had been written by a man named Raymond Gimel, so when the newspaper switchboard answered the phone I asked for him.

I was in luck. Gimel was the editor of the newspaper and happened to be there at the moment. His assistant warned me that he was busy and could only spare a minute. Fine with me, I said. That's all I need.

In that minute I learned from Gimel that some years before in Marseilles he had, quite by accident, encountered the illigitimate daughter of Vincent's sister Elizabeth. Her name was Hubertina and she had been selling calendars door-to-door.

Gimel said: "I cannot tell it all to you over the telephone. It is a long story and I am busy now."

"Could I come down to see you? You can name your date."

We set a date two weeks away. It was the first free weekend I would have.

This time I took the overnight train, which would at least give me the opportunity to get some sleep. Or so I thought. Even though I had taken care to equip myself with a sizeable flask of the marvelous gin which the Dutch

call *jenever* and a wildly boring mystery novel, I couldn't close my eyes. To make things worse, somewhere between Nice and Marseilles the train broke down. And worse still, it broke down not overlooking some pleasant moonlit rustic scene but in a railway siding near Cannes.

For a couple of hours we sat there. I searched out a conductor to find out what the problem was, but he knew about as much as I did. His job was to collect tickets; that the train was supposed to *move* seemed an issue with which he had nothing at all to do. I asked whether I could leave the train to walk around. The answer was an emphatic "Non!"

So back to my compartment. My flask of gin was nearly empty, I had finished the book somewhere in northern France, and I was slowly going mad. Perhaps this trip was a mistake. Surely I could have accomplished what I wanted to with a letter, I told myself.

But writing a letter would have gone against my instincts. After all, a letter to Mrs. Maynard in Devon wouldn't have accomplished much. You seemed to get most out of anything when you handled it personally. And anyway, I had always wanted to see the fish market in Marseilles. The bouillabaise there was supposed to be great.

So here I was, thinking about Vincent and fish soup, and staring at a brick wall. The fish soon gave way to sheep, thousands of which I must have counted in an effort to force myself to sleep. No luck.

After about three hours, the train suddenly moved forward. It was a short, abrupt move, but a move nonetheless. A few seconds later we moved again—this time backwards. I held my breath. Nothing. But then . . . another move forward. Then another move back. This happened about twenty times. After that, nothing. At least the driver gave it a try.

The scene reminded me of the story I heard at school about King Robert the Bruce of Scotland, who was stranded in a mountain cave. While sitting there, Bruce is

said to have watched a spider weaving its web. The insect would weave a lovely pattern and try slowly to build the web toward the other side of the cave. Every time it tried, it would get the web within a few inches of the opposite wall— only to have the web break. But the tiny creature persisted. It wove and wove, and finally made it, to the other side of the cave.

Bruce was impressed by the determination of the spider. In writing about the incident, he said that he had learned a simple principle from it: "If at first you don't succeed, try, try, try again." According to the legend, the spider and its lesson inspired Bruce to overthrow the English rule and liberate Scotland—which he finally did.

The lesson was not lost on me. A few weeks before, in Paris, my investigations had seemed to be making about as much progress as the train was at present.

My goal in Paris had been to find clues as to the fate of Agostina Segatori, owner of the Café Tambourin (which Vincent had frequented when he was living there) and one of his lovers. I also hoped I could shed some light on the identity of the mysterious "S," with whom Vincent, Theo and Andries Bonger had shared the apartment at 53 rue Lepic. They seemed to be trying to keep her identity a secret—and they had succeeded.

I had gone to the Paris archives in rue Henry IV to look through street directories, birth registers, death registers, marriage registers, anything that might give me a lead to either Segatori or "S." To make a long story very short, I failed. Segatori had disappeared without a trace, and "S" was nowhere to be found. I had hit a dead end.

To make matters worse, one of the librarians insisted on hanging over my shoulder the entire time I was there. Perhaps she thought I was going to make off with one of the leather-bound volumes. After all, they were small enough to fit into a steamer trunk, and couldn't have weighed more than fifty pounds. Anyway, she hovered over me—her

breath smelled of old garlic—like an overfed vulture. Not a nice way to spend a lovely spring day in Paris.

Thinking about that fruitless afternoon while sitting on the immobile train, I wondered whether my luck with Vincent had run out. Maybe I was wasting my time. Maybe I would never find anything that I was looking for.

But I couldn't give up yet. Vincent wouldn't let me. Like that spider in the cave, I had to keep going, at least to Marseilles—if I ever got there.

After five hours or so, the train gave a more promising heave. And this time it kept moving. My spirits immediately improved, and I settled back to re-read my novel. On to Marseilles.

We arrived there just before dawn. I walked wearily from the train station to the harbor, which was bustling with activity. Fishermen were hard at work, bringing in their great harvests. Millions of fish, from the tiniest sardine to the mammoth tuna, were piled on the icy marble slabs of the market. I watched with detachment through bloodshot eyes for an hour or so, then searched out an appropriate café for the bowl of bouillabaise I had promised myself. It lived up to its reputation, and I continued to watch the harbor as I slowly ate. I remembered Vincent's descriptions of harbor life in Antwerp.

Leaving the café, I walked up toward the other end of town. I had a couple of hours to kill before my appointment with Gimel, so I took my time, stopping at several places for coffee. At 10:00 I headed for the office of *Le Provencal*. I had woken up and was looking forward to speaking with Gimel.

The building where *Le Provencal* has its office is a large one. Later I was to learn that the newspaper has the biggest circulation of any in the south of France.

Gimel received me in his room. He was a thick-set, well-groomed man with an air about him of the seasoned journalist. He never asked a question that didn't have a point to it and he always listened closely to the answer. He

seemed more interested in me than I was in what he had to tell me. But eventually we got around to the point.

"Mr. Gimel, how did you come to know of Hubertina van Gogh?" I couldn't think of a more subtle way to ask the question.

He leaned back in his chair, looked up at the ceiling, and then spoke.

"It was a complete accident, really. One day in the mid-1960s—I'd have to check the year, they blend one into another—I came home from work to find my wife looking terribly upset. She told me that earlier in the afternoon an old woman had come to the house selling calendars for charity. They were looking through the calendar, and one of the reproductions was of a painting of a cornfield in Provence. It was by van Gogh. While they were looking at the picture, the woman suddenly said: 'My uncle made that.'

"My wife, a little surprised as you might expect, asked the woman what she meant. She said: 'That painting is by Vincent van Gogh. My name is Hubertina van Gogh. He was my uncle.'

"My wife asked the woman to sit down and talk for a while, which she seemed eager to do. In the course of their chat, the woman told my wife some of the details of her life. It was not a particularly happy life. Thus my wife's depression when I got home."

Armed with the woman's name, and with the information that she lived in a home for poor old people in Marseilles, Gimel tracked her down the next day. He went to see her at the home where she lived, and remembers the scene vividly.

"Her room reminded me of pictures of van Gogh's room in Arles. It was very stark and simple. The only decorations on the walls were a crucifix and an old calendar of van Gogh reproductions. Her clothes were old and frayed but, even in her eighties, there was nothing pitiful about her.

She had sharp lively eyes and, in spite of acute deafness, could hear a little with the help of a hearing aid. She spoke excellent French. And her face showed unmistakably the characteristic van Gogh features.

"I introduced myself and told her that I wanted to do a story about her in *Le Provencal*. She told me most of her life story. I wish I could relate it as movingly as she did.

"In the summer of 1886 Elizabeth Huberta, Vincent van Gogh's younger sister, was on holiday in Normandy with her husband-to-be, a Dutch lawyer named Jean Philippe Theodore du Quesne van Bruchem. At least, everyone thought they were on holiday. In fact, Elizabeth was many months pregnant. She gave birth to a daughter in the Norman village of Saint-Sauveur-le-Vicomte. That daughter was Hubertina. No one except the parents knew of the birth.

"When the couple did marry, they had another four children: Jeannette, Theodore, Wilhelmina, and Felix. But little Hubertina was left in Normandy. She was cared for by a young widow named Madame Balley, who owned a grocery shop.

"Hubertina told me that she believed du Quesne, her father, had wanted to take her back to Holland. But her mother Elizabeth refused. Apparently that side of the family was a bit more puritanical than the other."

After my recent conversation with the Engineer, I could easily believe that.

"Hubertina managed somehow to go to school, for she became a teacher. When her uncle was beginning to become famous, she was working in Paris. She was there in 1910, when her mother published a book called *Personal Recollections of Vincent van Gogh*."

I knew the book well. It was an inconsequential whitewash, designed mainly to save the family face from the more unsavory aspects of Vincent's personality. No doubt it went over well at respectable dinner parties.

"Hubertina always knew about her family and wondered about them," Gimel continued. "She told me: 'I knew I had brothers and sisters in Holland, but I didn't know if they knew about me. I would have liked to have gone to Holland to see them but never dared to. I would have been a stranger to them and maybe an embarrassment—the van Gogh family being what it was.' "

Gimel said that he tried to get Hubertina to elaborate on that last phrase—"the van Gogh family being what it was" —but she changed the subject.

"Hubertina earned a comfortable living until she was thirty-five. Then a severe attack of influenza left her very deaf. She had to give up teaching and couldn't find suitable work for many years. She became destitute and for a long while lived a life that she preferred not to talk about. 'I am ashamed of what I was compelled to do to keep alive.' She would not elaborate.

"After her father died, Hubertina received a letter from her sister, Jeannette, whom she had never seen. Apparently her father had waited until he was on his deathbed before confiding to his eldest legitimate daughter about the existence of Hubertina. When Jeannette heard that she had an illegitimate sister—who was not going to be provided for in her father's will—she was appalled and felt it was the least she could do to offer Hubertina half her share of the will.

" 'I refused,' Hubertina told me. 'I appreciated Jeannette's thoughtfulness but I did not want to deprive her. After my mother was widowed, she finally did write to me,' said Hubertina. 'She asked if I would like to come to her home in Holland as a maidservant.' Very charitable of her, don't you think?"

Legitimate daughter Jeannette never forgave her father and mother for the way they treated her sister.

"In search of work, Hubertina moved from Paris to Toulon, then south to Nice and Marseilles, where the only

work she could find was selling calendars for charity at doorsteps. It was while she was selling calendars that my wife met her."

When Gimel discussed Hubertina's predicament with some Marseilles artists, they were touched by the irony of the story. So the painters Toussaint d'Orgino, Antoine Ferrari and the brothers Ambrogiani decided they would donate the money earned from one painting a year to helping Vincent's neglected niece. How Vincent would have appreciated that gesture, I thought. It was just the sort of thing he would have done himself for a fellow human being in need.

I asked Gimel if Vincent's niece Hubertina had any contact with the painter's namesake nephew. He recalled that Hubertina mentioned having met Dr. van Gogh for the first time in 1951 at an exhibition of Vincent's paintings which was held in Arles. Hubertina said that the Engineer gave her a free ticket of admission to the exhibition and took her out for dinner in Arles. The Engineer also bought her a new hearing aid and sent her some money every once in a while.

"The last I heard of her was that she had moved to Lourdes, where she died not long after I met her.

There was a knock at the door and Gimel's assistant came in to tell him that he had another appointment. I think he was sorry to have to break off, but I had got what I wanted. We shook hands and I left. He asked me to keep him up to date on whatever I was doing with Vincent and, to my surprise, asked if I didn't mind being interviewed and photographed for the next day's edition of *Le Provencal*. It was fair enough.

After leaving Gimel's office, I walked slowly through the backstreets of Marseilles, turning Hubertina's sad story over in my mind. On the train back to Nice I decided that the first thing to do back in Holland was to ask Dr. van Gogh what he knew about his illegitimate cousin.

A few days later I was sitting once again in the Engineer's office at the van Gogh Museum. He had greeted me cordially, having forgotten, or so it seemed, the disagreements of our last visit. His tone remained cordial until I got to the point of my being there.

"Do you know anything about a woman named Hubertina van Gogh?"

He sat back in silence, a little surprised. I think he was trying to figure out how to respond. Once again he looked at me with that penetrating look. Finally he spoke.

"Yes, I knew about her. She is dead now." His voice was very quiet. He did not like talking about this.

"Did you know her?" I asked.

"I met Hubertina for the first time back in 1951, at an exhibition of Vincent van Gogh's paintings in Arles. I was just walking through the exhibition when a woman of about my own age approached me.

" 'I am your cousin Hubertina,' she said. I was shocked. I had no idea that such a person existed. We walked around and she told me the story of her life. I remember that when I told my wife she said: 'Oh Vincent, what a family the van Goghs seem to have been.' "

The Engineer seemed not to be very amused by this comment.

I asked him what further contact he had had with Hubertina. He said he had arranged through the Dutch Consul General in Marseilles to send Hubertina 300 guilders (about $120) and a smaller payment every three months. With his help and the contributions of the local painters, Dr. van Gogh said, Hubertina was able to leave the poorhouse and move to a pension.

"I continued to send her money for quite a while," said the Engineer, "until I began to be blackmailed . . ." He stopped abruptly.

"Did you say blackmail?" I asked.

He hesitated, then spoke with unmistakable anger in his

voice, "Yes, someone tried to blackmail me. I handed over all the correspondence to the Marseilles police."

"What form did the blackmail take?"

"Oh, it was a bunch of crooks. Don't ask me that. All I want to say is that I washed my hands of the whole affair." He was making it clear that he had nothing more to say on the subject. I said I must be going and stood up. Walking toward the door, I apologized for concentrating on what seemed to be the more unpleasant side of the van Gogh family's affairs.

"Oh, that's all right," replied the Engineer. "These things are unimportant."

Unimportant they may have been, but I wasn't going to stop until I had found out whatever else I could. After leaving the Engineer, I went back home and telephoned the Marseilles police department. I explained what I wanted to the person who answered the phone. He switched me through to someone else, and I explained again. That person transferred the call to yet another official, who listened and did exactly the same thing. After explaining myself to at least a half dozen Marseilles policemen, I finally spoke to the one who was supposed to know about matters of this sort. He listened silently and said that he did not have personal knowledge of the case but would look through the files.

He came back about ten seconds later. Clearly he hadn't looked very hard.

"I am sorry, monsieur, but we do not have records of any case such as the one you describe. Goodbye."

And that was it. The case rests, mystery to everyone except the Engineer—and someone on the Marseilles police force who, for some reason, doesn't want to talk about it.

As I hung up the phone, I thought about the Engineer's response to my question about syphilis and hereditary disease in the van Gogh family. He had dismissed the whole thing. Now, with his cousin Hubertina, he was being simi-

larly defensive. What was the blackmail attempt all about? Why was he so unwilling to talk about it? I was never going to get answers to these questions.

The life of Hubertina van Gogh was made miserable by the hypocrisy of her mother, who refused to acknowledge the existence of a child she had brought into the world. Her birthright was denied her. She was raised by a stranger to whom charity was more important than the "respectability" which Elizabeth van Gogh so selfishly valued. The belief in that kind of respectability seemed to have survived into the present day, in the Engineer's refusal to acknowledge any hint of disease in his family. What else might this rigid moralism try to conceal?

Hubertina died in 1969. No one is said to have attended her funeral, but a group of painters in Lourdes, where she died, gave a wreath of sunflowers to be placed on her grave. The sunflowers were a reminder of her connection with her uncle. Of him Hubertina had only one thing to say, when she talked with Raymond Gimel: "We had loneliness in common."

Chapter ten
Baby Willem

It was one of the greatest ironies of my involvement with
Vincent that the success I had with his article took more
and more of my time away from him. I found after doing
the article that I had acquired a reputation as a kind of art-
historical detective. People I didn't know were calling me
up to tell me about something they had heard about this
artist or the other. Would I please follow up their leads?
Could I tell them more about what they had heard?

This reputation—which I did my best to discourage—
also meant that I was being given numerous art-historical
assignments for the magazine. My article on M. C. Escher
was used to accompany the catalog of a retrospective
exhibition of his works at New York's Metropolitan Museum
of Art. After finishing it, I was given articles on Jan Vermeer,
Hieronymus Bosch, and master forger Han van Meegeren.
I was becoming an instant "expert" on all these men.

In addition, I had a multitude of other articles to do for
the *Holland Herald*. These took me as far away as Indonesia,
the West Indies, and South America. And they took time,
more than I could spare. But I had no choice: I was—and
am—a working journalist. Journalism takes as much time
after hours as it does between nine and five.

This meant that weeks and months slipped by, almost without my knowing it. The one opportunity I did have was a weekend in Paris, where I had initially failed so completely to find out anything about Vincent's love affairs there. This time I wanted to go and search out a bunch of names Vincent had scrawled on the backs of notebooks he had kept while he was living there. I spent a few days in the city archives, this time without the foul-breathed librarian peering over my shoulder. But my luck was no better. Apart from discovering that a pair of sisters whom Vincent knew had lived at an address near his and Theo's apartment, I came up with absolutely nothing. It was extremely discouraging.

I spent too many sleepless nights wondering when, if ever, I was going to get an opportunity to do what I really wanted to.

That opportunity didn't come until the spring of 1975, nearly a year after my trip to Marseilles. And it only came through misfortune. About five years before, in 1970, I had been knocked over by a car while crossing the Rozengracht, one of Amsterdam's biggest canal streets. The accident broke my collarbone and seven ribs, fractured my right leg in two places, and collapsed one of my lungs. I spent three months flat on my back (which fortunately wasn't broken) in a hospital bed. I left the place with a metal plate holding the fractured leg together.

It was that metal plate that gave me my opportunity to do some more research on Vincent. In March of 1975, I went back to the hospital to have the plate removed, a fairly easy and simple operation. But the weekend after getting out of the hospital, I spent an evening—the details of which are somewhat vague to me now—dancing at a party with my crutches in one hand. The next morning my leg hurt even more than my head, and I went straight to the hospital. They kept me there for three weeks.

I had all my Vincent material brought to me and I

spent my time reviewing it. What was I going to do after I got out; and what would I have time to do? I would have liked to go back to England, to dig around in more attics and try to find descendants of people whom Vincent knew, but that would be much too time-consuming. No, it looked as if I would have to stay closer to home.

Flipping through the notebooks from my travels, I decided that the most interesting question mark concerned Vincent's stay in The Hague. He lived there with a prostitute named Clasina Maria Hoornik, often called Sien, and her two children.

Vincent moved to The Hague, in the winter of 1881, shortly after his experience in the mines of the Borinage. He had spent about nine months at his parent's house in Etten, where he fell in love with his cousin Kee Vos. She, like Eugénie Loyer, rejected him. But whereas Eugénie's refusal channeled Vincent's passions into the Bible, his cousin Kee's "No, no, never!" drove him to a prostitute. He told Theo that he felt affection and love for prostitutes: they were his "sisters" in circumstances and experience. He was drawn to the "half-faded faces in which I see written: life in its reality has left its mark here." Thus, when he moved in with Clasina Maria Hoornik it was another significant turning point in his life.

Vincent was attracted to this woman because she could satisfy his sensual needs. But, just as important, she represented the kind of poverty and misery that he had tried to serve in the Borinage and to depict in his artistic work since then. She was an ideal object for Vincent's distinctive combination of erotic and compassionate love.

"If I repent anything," he wrote, "it is the time when mystical and theological notions induced me to lead too secluded a life. Gradually I have thought better of it. When you wake up in the morning and find yourself not alone, but see there in the morning twilight a fellow-creature beside you, it makes the world look so much more friendly.

Much more friendly than religious diaries and white-washed church walls with which the clergymen are in love."

For months Vincent did not mention to Theo in his letters that he was living with Sien. When he finally did tell him, he explained that she modeled for him and that he was thinking of marrying her.

When the prospect of marriage reached their parents' ears, Theo told Vincent that father van Gogh was thinking of sending him to a lunatic asylum. Even acquaintances in The Hague, the painter Anton Mauve and the dealer Tersteeg, were appalled when they found out that Vincent was living with this woman. Tersteeg spread the word around that Vincent was insane. But Vincent paid no heed.

He was in the hospital being treated for gonorrhea when Sien gave birth (on July 2, 1882) to a son they called Willem. As soon as Vincent was released from the hospital, he visited Sien and the baby. He was overcome with emotion.

"What I am most astonished at is the child," he wrote, "although he has been taken with forceps, he was not injured at all. He was lying in his cradle with a worldy-wise air."

To accommodate his growing family, Vincent moved into a larger apartment in The Hague (with financial help, of course, from Theo). He was overjoyed with his first— and what would be his only—experience of family life. He had told Theo often enough that he had always wanted to have a studio with a cradle. "I work from early till late at night and Sien poses for me." For Vincent, this was a home of his own and he had a passionate desire to believe in its permanence. He could not look at the cradle without showing emotion, and in his marvelous drawings of the baby Willem we can share something of what he felt. For in this unlikely household he found a passionate domesticity that inspired some of his most moving work.

In successive letters, Theo concentrated on trying to per-

suade his brother not to marry Sien, and Vincent continued to plead with Theo not to withdraw the financial support that he totally depended on. He wrote: "I know how only a short time ago I came home to a house that was not a real home with all the emotions connected with it now, where two great voids stared at me night and day. There was no wife. There was no child."

In spite of the mounting pressures from his family to leave Sien, Vincent would write to Theo: "When I am with them and my little boy comes creeping towards me on all fours, crowing for joy, I haven't the slightest doubt that everything is right. How often that child has comforted me. . . . When I am home he cannot leave me alone for a moment; when I am at work, he pulls at my coat or climbs up against my leg till I take him on my lap. . . . he crows at everything, plays quietly with a bit of paper, a bit of string, or an old brush; the child is always happy. If he keeps this disposition all his life, he will be cleverer than I."

But in the end Vincent did leave Sien and baby Willem. The van Gogh family insisted that Vincent practice morality in return for his allowance.

What happened to Clasina Maria Hoornik and the children? She would surely be dead by now, but was either of the children still alive? Did they have descendants who might know something of their background? These were the questions I felt compelled to find answers to.

When I got out of the hospital, I took an afternoon off and went to the van Gogh Museum to have a look through the letters Vincent wrote from The Hague and from Drenthe, where he moved after leaving The Hague. I discovered that there were more missing letters or parts of letters, more confusions of dates, than in letters from other periods. This was odd—the letters had for the most part been so superbly assembled and ordered.

Someone at the museum suggested I look up the art historian Jan Hulsker, who is the foremost authority on

Vincent's Hague period. Hulsker has assembled, sorted out and rearranged the letters from this period. If there were any answers to the questions I wanted to explore, he would certainly know about them.

When Hulsker and I spoke on the telephone, I explained that I wanted to discuss an entirely different matter and didn't mention Vincent's relationship with Clasina Maria Hoornik. A few months before I had been in Curaçao doing a series of articles. While there I learned of an art-collecting businessman who was said to have an unknown van Gogh painting. I went to speak personally with the man and he told me that in fact he had several van Goghs, all tucked away in different countries. He was planning to reveal them only gradually, over the years, but said that Jan Hulsker had already seen one of them and was studying it. I asked Hulsker if I could talk to him about these hidden canvases. He invited me to visit him at his home in The Hague.

I drove up to see him a few days later. He is a genial man with silver hair and a polite, restrained manner. We sat down to a glass of dry sherry and talked for a while about the collector in Curaçào. He had been appointed one of the official authenticators for the canvas in question and was currently inclined not to think it authentic. I told him my story about the drawing in Mrs. Maynard's attic, and we discussed the problems of authentication.

By the second glass of sherry, I got around, in a fairly subtle way, to the real point of my visit. I told Hulsker that I was interested in Vincent's Hague period but didn't know as much about it as I would like to.

"The prostitute he lived with—Clasina Hoornik. What was her background?"

Hulsker told me that she was born in The Hague on February 22, 1850. She was the eldest of her parents' eleven children. By the time she moved in the house (since demolished) in the street called Schenkweg, her daughter Marie was five years old. The girl's father was unknown.

I asked Hulsker if he knew what happened to Clasina and her family after Vincent left her. Said Hulsker: "I think the relationship was deteriorating. When Vincent left for Drenthe to mourn the separation, Sien handed the baby Willem over to her brother, Pieter Anthonie Hoornik."

"What became of Sien?"

"I believe she went back to prostitution after her household with Vincent broke up. She drowned herself in the early 1900s."

"And the baby Willem? What became of him?"

"I am afraid his destiny is unknown, at least to me."

But Hulsker did know something else that gave me a lead. He told me that Pieter Anthonie Hoornik (the brother of Sien's who was given custody of Willem) had a son of his own. And this boy became one of Holland's most noted poets, Ed Hoornik.

Hulsker told me: "I once asked Ed if he knew that the prostitute Vincent lived with in The Hague was his aunt. . . . He was amazed. He had no idea. But I do not know if he pursued the matter further."

Ed Hoornik died in 1970, but his widow, the well-known writer and broadcaster Mies Hoornik-Bouhuys, is still very much alive in Amsterdam. I made an appointment to see her. She lives in a canal house on the Prinsengracht, only a ten-minute walk from my own home on the Brouwersgracht. The Hoornik home differs from its neighbors by having thick ivy framing the windows.

Mies Bouhuys, as she is known, is a charming and intelligent woman. We had some tea and sat down to talk. She was intrigued by the news that I was trying to trace the descendants of Clasina Maria Hoornik—a certain light seemed to come into her eyes. I told her I had just been to see Hulsker who had told me that her late husband, Ed, was the nephew of Sien the prostitute.

"Oh yes, indeed. Hulsker told Ed about twenty years ago. I think Ed was greatly amused by the whole thing.

"I remember we were at a cocktail party. Hulsker took Ed aside and said that he had 'something to tell him in private, man to man.' Ed laughed at Hulsker's formality, and he told him that he had no secrets from his wife.

"Ed certainly got a surprise—particularly in view of the fact that he had *Sorrow*, Vincent's nude portrait of Sien, framed on the bedroom wall for years. Of course, he had no way of knowing that the dejected figure was his aunt!"

"Ed was curious—like you are now—to know what happened to his stepbrother Willem. He had lost contact with Willem when a youth. So we decided to try and trace him."

I asked Mies how they went about it.

"Ed had heard that Willem was employed many years before as a designer with the Rijkswaterstaat (State Water Works). And through this body he managed to trace Willem to an old folks' home called the Saint Servaas Bolwerk in Maastricht. That's down in the southern Dutch province of Limburg."

I underlined the name.

Mies and Ed decided to visit Willem in Maastricht. They drove down together one weekend in the fall of 1957. After locating the home where Willem was staying, they were shown to his room by one of the staff.

"When we walked into Willem's room, he was sitting at a desk with his back to us. The room was nearly barren of decoration.

"As we came closer, we saw that Willem had twelve sharpened pencils and several sheets of paper on the desk in front of him. He was drawing. Drawing very intently. It took several moments before he realized that we were standing only a few feet away from him.

"When he saw us, he jumped to his feet. He looked his age but his features were strong and angular, especially when etched against the daylight coming in through the window. There was something vaguely familiar about his face.

"Willem didn't know who we were, but when Ed introduced himself he was visibly moved. The two stepbrothers embraced—Ed was also moved. They had not seen each other since they were boys.

"We all sat down and Willem and Ed began to talk. Ed told Willem about his experiences during the war—he survived Dachau—and about his career as a writer.

"Willem listened attentively. He seemed glad to renew contact with a member of the Hoornik family. Clearly he felt out of touch with his past, and this meeting was a way of renewing that contact."

I felt that Mies Bouhuys was preparing to tell me something important and I edged forward in my seat. In doing so, I knocked over my teacup, which momentarily put a stop to her narrative as I stood repeating apologies and she insisted that I shouldn't worry about it.

When we sat down again, Mies resumed.

"Ed asked Willem what he had done, how he had come to work in the State Water Works, whether he had married, and so on. Willem looked uncomfortable, as if he had a secret to tell but wasn't sure whether he ought to. He looked at the ground and shuffled his feet back and forth. Then, in a somber voice, he told Ed that what he was about to tell him he had never told to anyone before. I can pass on nearly his exact words, so carefully did I listen. You know how it is with us journalists. When he began to speak, I turned on a little tape recorder in my head. I will never forget his words, though I've barely thought of them since that day."

With that, Mies half closed her eyes and looked into space as she quoted Willem's words to me.

"I always had the impression that my mother never really wanted to give me over into the care of her brother. She used to visit me secretly at school in The Hague and give me sweets. I remember my stepfather took me to Rotterdam to visit her one day. It must have been around 1900. He

thought it necessary that I have a legal surname, you see, for fear of discrimination when I joined the army. He asked my mother if she would get married so that I would have a legal father.

" 'But I know who his father is,' said my mother. 'He was an artist I lived with nearly twenty years ago in The Hague. His name was van Gogh. Vincent van Gogh.' She turned toward me. 'You are called after him,' she said. 'His middle name was Willem.' "

I must have made a noise, because Mies Bouhuys looked at me with a strange look on her face. She didn't comment, but went on with her story.

"Of course, the name Vincent van Gogh meant nothing to me then. I only made a note of the name because he was my father. I had no idea how famous he would become later.

"Anyway, my stepfather persuaded my mother to marry a sailor called van Wijk. Van Wijk received 300 guilders in return and went back to sea, I suppose. That is how I became officially Willem van Wijk. But I have always known I was the illegitimate son of Vincent van Gogh."

Asked why he had kept this secret to himself all his life, Willem replied: "When I was younger I used to tell myself that one day I would tell the world. But the older I got, the less I wanted to. I have been living in a rather strict community, and I admit that I did not want people and my family to know that my mother was a prostitute. I think it would have made my life unbearable if they had known that here. Not even my wife knew about it. She is dead now.

"For the past few years I have been living from room to room. Not very happily. I rarely see my son and daughter. But I do love to draw. Sometimes I sit with my pencil and wonder. . . ."

The expression on Mies' face changed as she seemed to come back to the present. She sat in silence for a moment, then spoke again.

"I realized after Willem finished speaking why his face looked familiar. There was such a strong resemblance between him and Vincent van Gogh—the high forehead, angular nose, brooding lips. When he held his head at a certain angle the resemblance became even stronger.

"Willem was upset by these memories. We left him quietly and promised to return. We did not speak for most of the drive back up to Amsterdam."

"And did you ever return?" I asked.

"Ed returned about a year later, in 1958. Just before Willem died. Ed told me that Willem cried openly when he talked about his mother. His last thoughts were of her."

I asked Mies if Ed had published any of this.

"He always wanted to write about it one day, but never did. He was so busy."

"And yourself," I said. "Did you never discuss it with anyone or write about it?"

Her answer was one I had heard several times in the course of my investigations.

"No one ever asked me."

"I'm glad I did ask."

"What do you think you will do with what I have told you?"

"I will publish it, but I'm not sure in exactly what form yet."

"If you would like me not to talk about it to anyone else, I will be glad to cooperate. It's been sitting with me for so long I shouldn't have too much difficulty keeping quiet about it now."

"That is very kind of you. Yes, I would appreciate your keeping it to yourself. Thank you very much. Thank you for talking to me."

Mies Bouhuys showed me to the door and we said good-bye. I was full of admiration for this woman.

When I left Mies' house, I walked around the canals for a couple of hours. Needless to say, I was shocked by what she

had told me. I'd never expected anything like it, even though I had thought there was something slightly mysterious about Vincent's relationship with Sien.

Suddenly the missing letters and sections of letters from The Hague period took on a new significance. Were they cut out of the "official" body of letters deliberately? Was someone in the family trying to hide the true nature of Vincent's involvement with the prostitute Sien?

As far as I was concerned, the importance of this finding surpassed Mrs. Maynard's drawing by miles.

And I was deeply moved. Moved by the reunion between Willem and Ed Hoornik after so many years of separation, moved by the thought of Willem living most of his life with a secret he was too frightened to divulge to anyone. But moved most of all by the pathos of Vincent's dilemma. He had wanted so desperately to find love, have a family. His descriptions of the joy he felt at seeing the baby Willem crawl across the floor are some of the most beautiful words I had ever read about fatherhood and family.

All this was taken away from him by the restrictive moralism of his own family, and even of his friends.

I must have walked around for several hours because, when I next looked at the sky, night was falling. The sun had still been fairly high in the sky when I left Mies Bouhuys. Time to go home. I had to figure out what I was going to do with my new information.

The first thing was to find out more about Willem van Wijk, or Willem van Gogh, as he ought to be called. Mies had not said where he was buried. Come to think of it, she hadn't said whether he was buried or cremated.

I also wanted to find Willem's children, to see what they knew about their father and grandfather. Mies knew no particulars of them. I would have to do it all myself.

And after I had found out what I wanted to, I would go and talk to Dr. van Gogh.

That night I dashed off a letter to the local authority in

Maastricht asking if they had any information about a man called Willem van Wijk, born 1882, died 1958-60, resident of Saint Servaas Bolwerk old folks' home, Maastricht. Please contact me at blah blah, so on and so forth. I went out and posted the letter immediately. I couldn't wait until morning.

As I lay in bed that night, I wondered about the conversations I would have with Willem van Wijk's children, if I ever found them. . . .

"Good morning Mr. van Wijk, did you know Vincent van Gogh was your grandfather?"

"No, I didn't. Come in. Tea or coffee? One lump or two? . . ."

Or maybe it would be:

"Yes, I did. So what?"

I wanted first of all to go to the cemetery where Willem was buried and photograph his gravestone. I'm not sure why I wanted to do this first, really. Perhaps because the first thing I had done on my assignment for the magazine was photograph the tiny gravestone of Vincent van Gogh, the boy who had died stillborn a year before his brother, the painter, was born. Or perhaps it was simply the easiest thing to do. In my journeys I had become used to cemeteries—I had spent so much time in them they no longer bothered me as they do some people. People seemed to suffer their torments before they descended to the grave.

Anyway, to the cemetery I went. It seemed large even for a city of over 100,000 inhabitants—large enough, I thought, to accommodate the entire province. Thousands of graves, from the humblest stones to the grandest family shrines, were shielded from the sun by weeping willows and tall cypress trees—Vincent's symbol of death.

I rapped loudly on the rusty latch of the cemetery-keeper's door. Silence. I rapped again. This time I heard a shuffling noise inside the gatehouse and a clanking that sounded ominously like chains. Then a key being put into

the lock from the other side and turned slowly. Finally the door creaked open. By this time I expected to see a corpse in a white shroud.

Instead there was a huge man with dark eyes that seemed to be floating in the back of his head. I couldn't tell whether he was looking at me, past me, or through me. It took a moment to gain my composure and tell him the grave I wanted.

"Van Wijk, van Wijk. . . . Can't say I recognize the name. Come in, please. I'll have a look at the plans."

I followed him into the gatehouse, a dark and slightly damp-smelling place. He took one of his enormous rusty keys and opened a cupboard, from which he took a dusty register that seemed as if it had been there for a few centuries. If not more. I looked over his shoulder as he turned the pages, found the page he needed, and then scanned his eyes down the page.

"The grave you want is Lot 1054," he announced. "It's over on the other side of the cemetery, and you'll never find it by yourself. If you can wait a minute, I'll walk with you. I have to do something over there."

He seemed glad to have the company, and I didn't feel like wandering around lost all day, so I agreed.

As we walked the keeper talked about his job, about how few people he saw. "You are the first registered visitor that Mr. van Wijk has had. Are you a relative?"

"No, not a relative."

"Oh, a family friend I suppose . . ."

"I guess you might say that."

At the end of a long pathway he pointed me in the direction of Lot 1054. I thanked him and he went on his own way.

Like Vincent's grave in Auvers-sur-Oise, Willem's grave is the simplest around. Just a simple stone.

A slight drizzle had started up and I pulled my coat around my ears. As I stood there, a phrase from one of

Vincent's letters came back to me: "What will be the fate of my poor little boy?" I thought again of his descriptions of the baby "crowing for joy" and tugging at Vincent's smock while he was painting. Now that little boy lay here, unvisited, seemingly forgotten. My breath stuck in my throat.

The happy little boy was the last of Willem that his father had seen. What became of him after that? Did he have a happy life, in spite of his sad secret? Had his secret affected him? What kind of character was he?

To find out, I would have to trace his family and friends. Perhaps they would answer Vincent's question about his "poor little boy." I made a few photographs of the grave and left. I had not been so deeply moved by any of the other graves I had visited as I was by this one. Perhaps it was simply the fact that I couldn't help but think of Willem as that baby crawling across the floor of Vincent's studio. I tried to banish the image from my mind and concentrate now on the grown-up Willem, the man that his friends and family knew.

I drove back into Maastricht and went first to the Saint Servaas Bolwerk, the old folks' home where Willem had lived. The matron, an officious and severe woman in a black tunic, told me that there was no one there who remembered Willem. But she did check the records and told me that he had died of stomach cancer.

My next visit was to the offices of the State Water Works, where Willem worked as a draftsman. From the outside the place was exceptionally unfriendly, a gaunt neo-Gothic prison that looked quite out of place in the sunshine. From the inside, it was even worse: full of long dark corridors and creaking doors, and apparently suffering from a shortage of people. With an atmosphere like that, I wasn't surprised.

After asking a few people I ran into in the corridors, I was referred to an information desk on the first floor. At the information desk I enquired whether there might be anyone still working there who knew Willem van Wijk.

The man behind the desk looked at me a little suspiciously.

"Are you a relative of van Wijk?"

"No, I'm a journalist doing some research about his family."

"Van Wijk has been dead almost twenty years, you know. But I will see what I can do."

"Thank you very much." He picked up the telephone, dialed a couple of numbers, and began speaking in the Limburg dialect, which I don't easily understand. After a few minutes he put down the telephone and turned to me.

"If you go up to room 137 there may be someone there who can help you."

Waiting for me in room 137 were two old men named Anthonie Balthusen and Victor Koekkelkoren. They sat silent and upright in wooden chairs. I introduced myself and explained what I was looking for.

"Van Wijk," they said almost simultaneously. Apparently it was the custom here to address and refer to people by their last name only—even if, like these two, they have been working together for twenty-five years.

"Van Wijk," they said again. I could tell by the way they said the name that their memories were less than favorable. Koekkelkoren was the first to speak.

"If you ask me for good things, there's not much to say."

I asked whether he had any memories of specific incidents that made him dislike Willem. He shuffled nervously in his seat but didn't say a word. I turned to his colleague.

"Do you have anything to say about van Wijk, Mr. Balthusen?"

"There's a lot I could say, but I won't."

Silence again. I couldn't quite believe their unwillingness to talk to me.

"Is there anyone else who might be able to tell me more about van Wijk? I've come all the way from Amsterdam."

They didn't say anything for a few moments. Then Balthusen spoke.

196

"There was one fellow here at work. He is no longer here. His name is Johannes Feij. I think he knew van Wijk better than anyone else did. I don't know where he lives now, but it is probably in Maastricht. Talk to him. He might have something to tell you."

I could tell that they had given me as much as they were going to. I rose and, with a bit of irony that I couldn't resist, said, "Thank you so much for your help, gentlemen." They didn't see the joke. I gave up and left.

I stopped at the first phone booth I passed and looked up the address of Johannes Feij. He lived near the cemetery which I had already visited.

I was about to telephone him when I got the idea that it might be better to drop in unannounced. People seemed so unwilling to talk about Willem . . . maybe if I took him by surprise Johannes Feij would open up more easily. So I drove to the address given in the telephone directory.

Luckily, Feij was at home. A thin, fairly lively man in his seventies, he was willing to talk and invited me in to his house. Over tea and biscuits, he told me about Willem van Wijk.

"I worked under Willem from 1924 to 1938, but knew him for quite a while after that. He was an enclosed person. Embittered, I would say, and certainly a difficult man. He kept very much to himself.

"During the war Willem was a member of the Nationalist Socialist Party and a sympathizer with the Nazis. They had the freedom of his house during the occupation. Of course, this alienated a lot of people. I remember just after the war seeing him being transported to the concentration camp at Vught to be tried with other alleged collaborators. But he was not confined for very long, I don't think.

"His wife, Saakje Leistra, left him during the war. I heard that she committed suicide shortly afterwards.

"I always felt with Willem that he had things preying on his mind. But he never talked about them, whatever

they were. An odd thing I noticed was that he always signed himself *Willem van Wijk, zich noemende Hoornik* [literally, calling himself Hoornik], a very unusual practice in the Netherlands."

Feij had the impression that Willem's childhood had not been a very happy one.

"I remember he told me that as a child he was forced to walk for three hours to piano lessons. I think he harbored some resentment toward his family. Yes, I'm sure he did. He told me once that the writer Ed Hoornik was his step-brother and he would show great interest, I remember, when a new Hoornik book would be published. But as far as I know he had no contact with him."

Feij knew nothing about Willem's mother. Neither did he know where his son and daughter were living.

He did give me the name of Mrs. Toos van Dijk, who was a neighbor of Willem's before he moved into the old folks' home. I visited her next.

Mrs. van Dijk told me that Willem had "a slightly sarcastic humor and was a bit bitter but had an aristocratic air and was very charming. He drew magnificently. His lettering was beautiful."

Mrs. van Dijk could not tell me much more about Willem. They were good neighbors, she said, but didn't know each other well. Nor could she tell me the names of anyone else who might have known him. Being forced to abandon that line of enquiry, I decided next to try and find Willem's son and daughter.

To do this I followed the same procedure Paul Chalcroft and I had used in London to track down Kathleen Maynard. I went from Mrs. van Dijk's house to the Maastricht archives to see Willem's death certificate.

It took only a few minutes for the registrar to find the certificate. On it were two names: Willy van Wijk and Yosta Eerens-van Wijk. I got a photocopy of the certificate and went out to find a telephone book.

Now I faced the problem I had been thinking about a few nights before in Amsterdam. If I was right, these were the grandchildren of Vincent van Gogh. How was I going to tell them? What would they say? I was as nervous at that moment as I had been at any time in the whole of my investigations.

Van Wijk is a very common name in Holland—like Smith or Jones in America and Britain. So I tried Yosta Eerens-van Wijk first, thinking that it would be easier to find. There was no one of that name in Maastricht. I looked through a few of the nearby towns and, by luck, found the name in the listing for Herten, a village just outside Maastricht proper. Plucking up my courage, I dialed the number.

A woman's voice answered the phone. I spoke very nervously.

"Hello, Mrs. Eerens-van Wijk?"

"Yes, this is she."

"Good afternoon. My name is Kenneth Wilkie. I am conducting some research into the Hoornik family and to help in that research I need some information about your father."

Her reply was immediate and to the point.

"Anything you want to know about my father you had better find out for yourself. You will not get it from me."

And she hung up the receiver.

I called her right back.

"Mrs. Eerens-van Wijk, I . . ."

Click.

I tried again. This time she gave me the chance to ask her whether she wouldn't speak to me for five minutes only. I was quite willing . . .

Receiver down again.

I tried once more. This time her husband came to the phone. His only words were: "You won't find out anything from this family."

I couldn't understand it. Had I lost that telephone charm I once possessed? Perhaps I was losing my touch.

But Yosta Eerens-van Wijk's reaction suggested that she was afraid of something, or was hiding something. What was it?

I hoped I would have better luck with Willy, Yosta's brother.

Johannes Feij had told me he heard that Willy moved to somewhere in the Rotterdam area, but he wasn't sure about it. Anyway, it was better than nothing. I got out the Rotterdam phone book and looked up the W. van Wijks. Just as I had feared, there were dozens of them. I went to a nearby café, got a sandwich and a glass of beer, and went back to the phone booth armed with a pocketful of coins. I knew it might take me an hour's worth of calls before I got the right W. van Wijk.

I was right, or nearly so. I went through many names and numbers, each time asking the question:

"Did your father die in Maastricht in 1958? Was he named Willem and was he born in 1882?"

No one was impolite, but some of them clearly thought I was crazy. Finally, one man answered positively. He seemed to take the question quite casually.

I explained to him that I was doing research into his family and might have something of interest to tell him. If I could possibly pay him a visit . . .

"Yes, yes, please come to my office in Rotterdam next Saturday. I will be there all morning and would be happy to talk to you."

We made arrangements and I hung up the phone. The difference between his reaction and the reaction of his sister was quite astonishing. I looked forward to meeting him. The two-hour drive back to Amsterdam was a jubilant one.

I could barely keep my skin on till the appointed Saturday. It was only Wednesday when I went to Maastricht and

I had to wait two agonizing days. I went back to work but couldn't think about anything but that drive to Rotterdam.

When the day arrived, I was up at dawn, even though Rotterdam is not a long drive from Amsterdam and I wasn't meant to be at Willy's office until ten. I simply couldn't sleep. I tried to prolong everything I did—my morning shower, walking the dog, reading the newspaper— just to kill time until I left. I even drove intentionally slowly down to Rotterdam.

Willy van Wijk's office is in the tree-lined Mathenesser-laan, one of the few streets that escaped the barbaric Nazi bombardment in World War II. I rang the bell and waited.

When the door opened, I got the shock of my life. The man who introduced himself as Willy van Wijk had the distinctive van Gogh features—the high forehead, large, thin, hooked nose, long head. I masked my amazement as we shook hands and he led the way into his office. But as he made coffee and we talked about the weather, that family resemblance was all I could think about.

"Would you care for a dash of cognac in your coffee?" he ventured.

"I think I could use it."

We sat drinking the fortified coffee in silence for a few moments. He seemed exceedingly friendly—certainly not threatening the way his sister had been—but I think he could tell I had something big on my mind. Finally I got around to the point. I asked him again who his parents were. Same answer. Then I asked whether he had known his grandparents. No, he hadn't.

I paused, wondering still how I was going to say this. I put down my coffee cup.

"Mr. van Wijk, my interest in the Hoornik family is in truth related primarily to another family. Can I rely on you not to repeat to anyone what I am about to tell you now?"

"Why, yes. Certainly of course. But do tell me."

"There is strong evidence that your grandfather was Vincent van Gogh."

Willy fell back into his seat. His jaw had dropped, his eyes were wide open. He was speechless.

I told him how I had come to this conclusion, how his father had told the story to Ed Hoornik and Hoornik's widow had told it to me. I explained the circumstances in which Vincent had lived in The Hague and about his relationship with the prostitute Sien. Willy, unlike some other people, seemed not to worry about having a prostitute in the family. I showed him copies of the drawings Vincent had made of Willy's father when Willem was a baby. Willy, still speechless, looked at the pictures. Finally he spoke.

"My father told me none of this. It is amazing. Incredible. I just can't believe it."

When a bit of the shock had worn off, Willy began to comb his memory for clues.

"I always sensed that there was some mystery surrounding my father's family, but I never had any idea what it was. To tell you the truth, I never became close enough to my father to ask him anything at all personal. . . . You know, I think I could use another cognac."

He poured a trickle into both our cups and continued. "I remember my father had a drawing he was very attached to. It was of a laborer. I think it was signed 'Vincent.' "

I indicated my surprise.

"Yes, yes—I remember him saying it meant something special to him, but he wouldn't tell me what."

"Where is the drawing now?" I asked.

"It's with my sister Yosta in Herten."

"Are you sure you remember the name Vincent on the drawing?" I wasn't jumping to any conclusions, realizing that the entrance of van Gogh into his life might have affected his memory.

"Well, I can easily phone her and ask."

He picked up the telephone and dialed his sister's number.

"Hello, Yosta? It's Willy. You know that old drawing of Dad's that you have on your wall? The one he liked so much? Could you please do me a favor and check the signature?"

The moments passed very slowly as we waited for Yosta's return to the telephone. I struggled not to get my hopes up. What if Vincent had given Sien a drawing . . . and she had passed it on to her son . . . and . . .

Then Willy spoke into the receiver.

"Hello? Yes, yes . . . Oh, well . . . thanks . . . Yes, no. I just wanted to check. I thought it might have been something else. Yes . . . yes . . . goodbye. Thanks a lot."

He put down the receiver and looked at me.

"She says it has some other name on it. Not Vincent. I was mistaken. I'm very sorry. I'm not thinking very straight at the moment."

I was sympathetic, having been disappointed in a similar way once or twice. "It's all right," I said. "You must have van Gogh on your mind." I went on to ask Willy about his father's background.

"He had a Catholic upbringing in the Hoornik family, but the woman he married—Saakje Leistra—was a Protestant from the northern province of Friesland. That's really all I know. They were divorced in 1941 and she died four years later."

I didn't think it appropriate to ask whether she had killed herself, as Johannes Feij had said.

Willy continued: "Dad was a very creative person, as you know. I remember he designed and made electric trains and warships for me when I was a boy. My sons, one is twenty-seven and the other is thirty-two, don't seem to have any artistic leanings. Neither do I, you know."

I asked Willy whether he had any photographs of his father. All he had were a tiny passport-type picture and a

couple of badly printed family album shots. At least from the passport photo I was able to get an idea of what Willem had looked like later in life. Funnily enough, he looked less like Vincent than did Willy, Vincent's grandson.

Willy gladly gave me the photographs and again promised not to talk about our conversation until I gave him the OK. We had a last cognac—this time without the coffee—and I was off.

On the drive back to Amsterdam, I thought about what I had found. Willem van Wijk, or Willem Hoornik, or Willem van Gogh—who was he? A man who had been a Nazi sympathizer during the war. A secretive man who had never talked about "personal" subjects with his son. A man who was disliked, it would seem, by the men he worked with. A talented artist, but known to one of his few friends as a sad and embittered man.

I realized that I would never know as much about him as I wanted to. He had lived long enough to tell two people his tragic secret—at least that hadn't died with him. All that was left of him now was a cluster of memories—many of them unpleasant—in the minds of the people who knew him.

But there were still his children, one of whom still didn't know the identity of her famous grandfather. They were all his family, apart from Willy's two sons and whatever children Yosta might have. But there was also the Engineer, Dr. van Gogh, who would be Willem's cousin. Did he know about Willem? If so, he hadn't acknowledged the fact. And he certainly had made no provision for Willy, Vincent's grandson, in the financial settlement of the huge van Gogh estate. Legally, I assumed, there was nothing that would require him to do so. But wasn't there a moral obligation to acknowledge the existence of this branch of the van Gogh family? Shouldn't the Engineer know about his cousin, and his cousin's son?

I decided that I would go to see the Engineer. He often

worked at his office in the museum on Saturdays, and perhaps I might find him there.

This was without question the most frightening prospect of my investigations. I remembered too well the coldness with which the Engineer had greeted my questions about Vincent's syphilis, and about mental disease in the family. I had no reason to believe that he would take my present news any more enthusiastically.

As I parked my car near the Museum and walked across Museumplein, my palms were sweating the way they used to when I had to recite in class. I could almost hear my buttons clattering from the violence of my heartbeat.

I felt like I was going to my doom.

The irony of it was that the Engineer, dressed as always in his striped bow tie, greeted me politely as he always did. Perhaps he couldn't believe that this pestering journalist was really going to make trouble for him again. But was there, I thought, a little more strain in the cordiality than there had been before? I couldn't tell.

After the customary few minutes of small talk, I began explaining to Dr. van Gogh why I was there.

"As you know, sir, I have continued exploring certain questions having to do with Vincent van Gogh's life. Most recently I have been interested in the period he spent in The Hague, when he was living with the prostitute named Clasina Maria Hoornik."

At the word "prostitute" his eyes narrowed the way they did when he was expecting something unpleasant. I gulped and continued talking. I wasn't going to let him frighten me. Not that he was trying to, at least consciously.

"I was interested in tracing what happened to the woman, and to her children, after Vincent left them. As you know, family pressure forced him to desert Sien (as Clasina Maria was called) and her children.

"I went to see Jan Hulsker, whom you know well. He told me that Sien was related to the writer Ed Hoornik and

that Hoornik's widow Mies Bouhuys might have something interesting to tell me. To be as brief about it as I can, she did."

The Engineer was listening motionless and expressionless, but he was listening. I proceeded to tell him the whole story of what Mies Bouhuys told me, of my visit to Maastricht, and of my conversation with Willy van Wijk. I concluded by asking him whether he had known of Willem before, and whether he had any plans to contact Willy van Wijk.

The Engineer sat silently. He was looking directly at me in the penetrating way he had. When he spoke, his voice was more agitated than I had ever heard it.

"Now let's get it straight. I don't know anything about this. My only source of information is the letters, and I have published all that have been handed down to me—apart from a few unimportant jottings. My mother never mentioned the name Hoornik to me. She probably didn't know about this or she would have told me."

"And you," I asked, "what do you think of it?"

"Personally I don't think this man van Wijk was Vincent's son or Vincent would have said so in his letters . . ."

I interrupted him. "But there are sections missing from the letters he wrote in The Hague . . ."

"That doesn't prove anything. I think it more likely that Sien wanted to clear herself in her son's eyes when she told him that Vincent was his father. She probably didn't want him to know that she had had so many men.

"If you knew more about that period you would see why Sien probably was not telling the truth. In the 1880s the upper and lower classes in The Hague had very loose morals. It was only the middle class who exercised moral restraint then.

"I admit that in the 1914 edition of Vincent's letters a lot were left out because Vincent's sisters were still living. But in 1953 I published everything I had. If there are parts of

letters and complete letters still missing, I do not know what happened to them."

The Engineer had been sitting forward in his seat while talking to me. Suddenly he sat back and changed the subject. We talked for a few minutes about Vincent's life in London and other unrelated matters. Obviously the Engineer had no desire to talk to me any longer. I politely took my leave.

I was furious with the way the Engineer had rejected my findings out of hand. He disbelieved Sien simply because she was a prostitute. That, coupled with his statements about the "loose morals" of the lower classes in The Hague, seemed further reflections of the puritanism he had displayed in our discussion of Vincent's disease. And to argue that Vincent would have admitted Willem to be his own son—well the Engineer knew how puritanical Vincent's family was. Surely he couldn't believe that Vincent would endanger the financial support and approval he so valued.

The Engineer, it seemed to me, was a man who refused to acknowledge whatever was uncomfortable to discuss.

After leaving his office, I went to a phone booth to call Jan Hulsker. I told him about what I had found and asked his opinion on whether Willem really was Vincent's son.

Hulsker acknowledged the validity of my evidence, but said that it must still be regarded as "an open question."

I couldn't argue with him. The evidence is there for anyone to see. Perhaps someone else will go beyond my discoveries, prove them wrong or substantiate them. Perhaps new documents will come to light and there will be no need for argument, or for stubborn refusal to argue. My investigations have proved, if nothing else, that the evidence is still out there waiting to be found.

But it probably will not be found by me. The search that began with a magazine assignment has come, for the time being, to an end.

Picture Credits

Pages 124, 127, 136 (bottom), 137, 138, 139, 140–1, 143, 144, 145, 148 and 151: Courtesy of the Vincent van Gogh Foundation, Rijksmuseum Vincent van Gogh, Amsterdam. Pages 125, 126, 128 (top), 131, 135, 136 (top), 142, 146, 147 and 149: Collection of the author. Pages 128, 129 (top), 130, 132–3: Collection of Mrs. Kathleen Maynard. Page 129 (bottom): Patrick Smith Associates, Ltd. Page 134: Collection of Jean Richez. Page 149 (top): Lia Schelkens, Amsterdam. Page 150: Kröller Muller Foundation, Otterlo. Page 152 (top): Collection of Willy van Wijk, Amsterdam. Page 152 (bottom): Wim Ruigrok, Amsterdam. Page 153: Ted Dukkers, Amsterdam.